Barcelona

The palimpsest of Barcelona

Barc

elona

text **Joan Barril** photography **Pere Vivas**

TRIANGLE ▼POSTALS

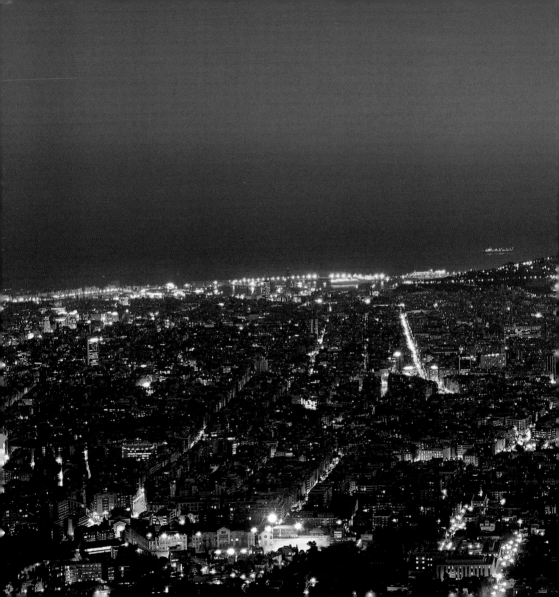

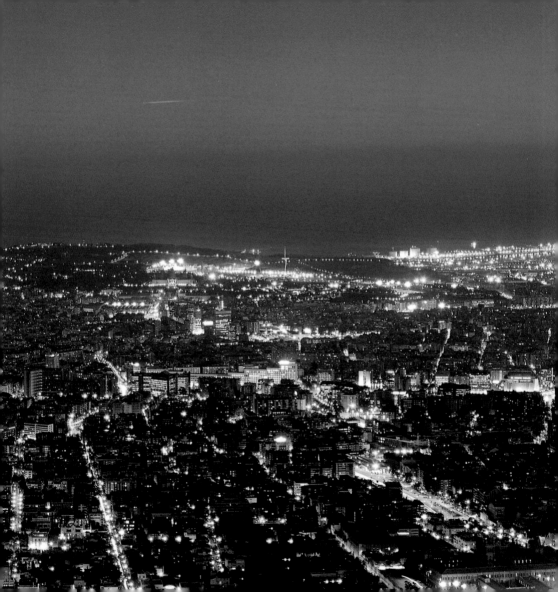

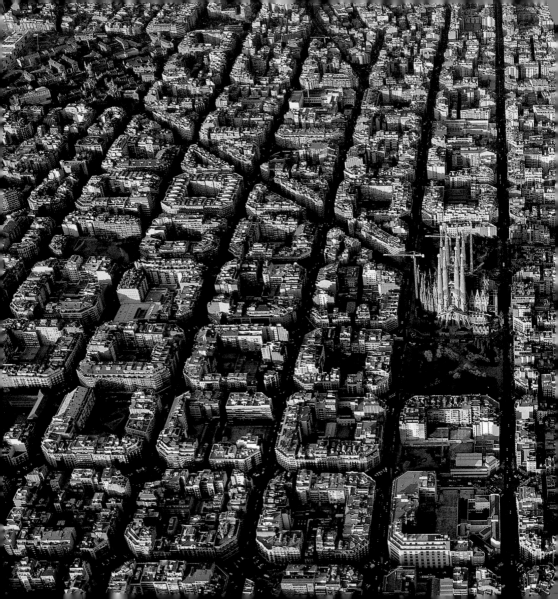

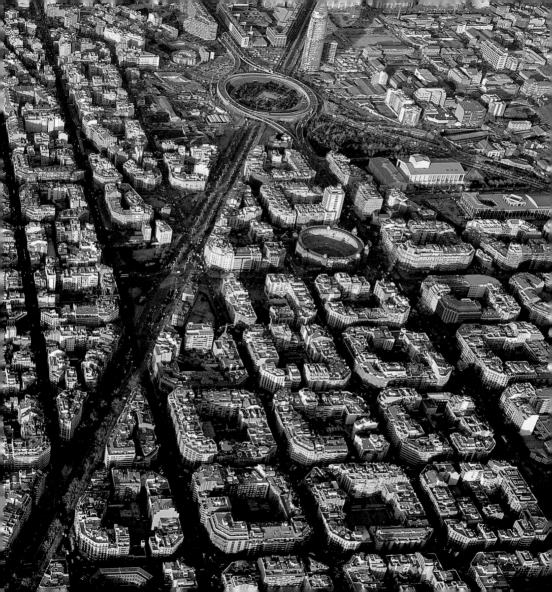

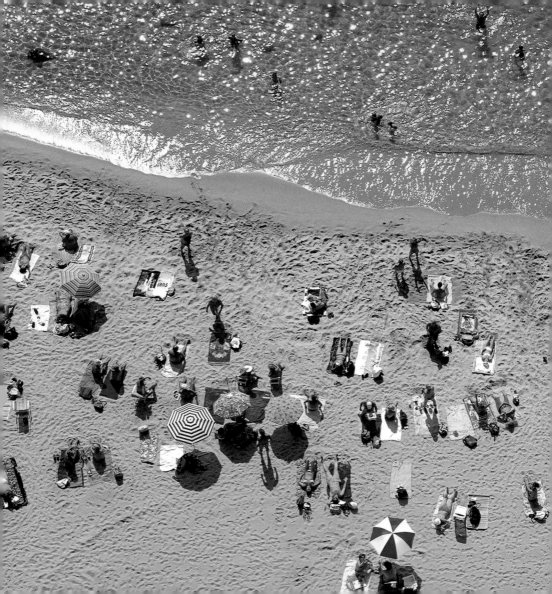

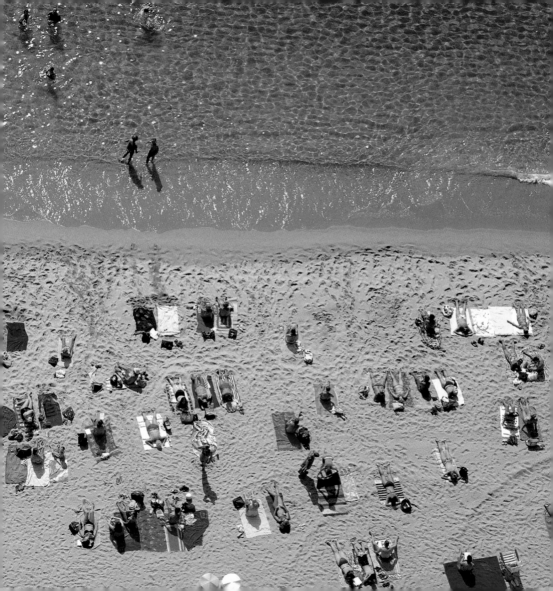

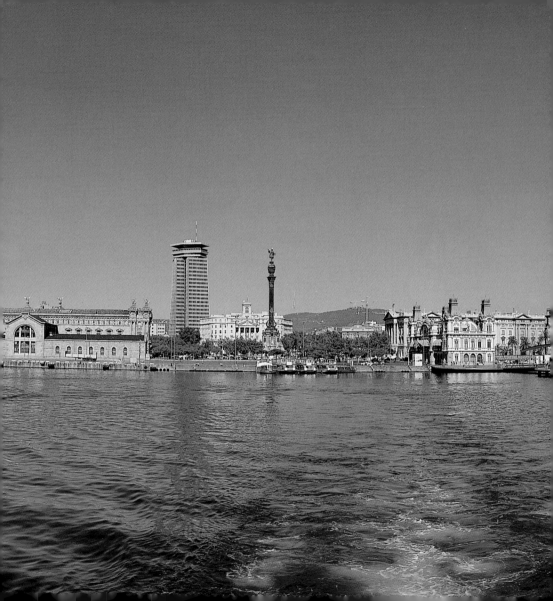

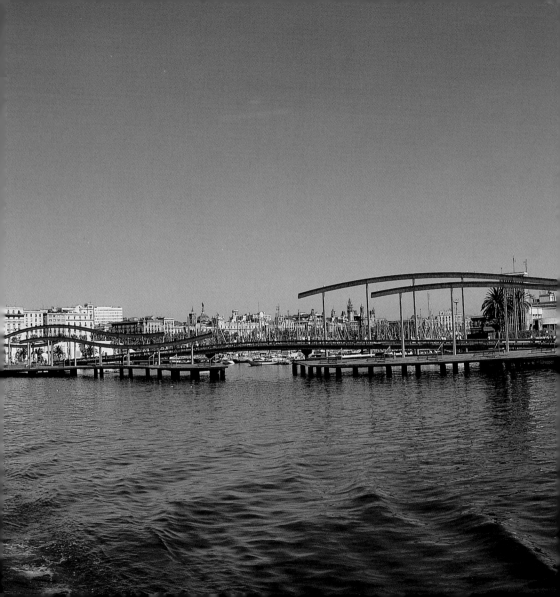

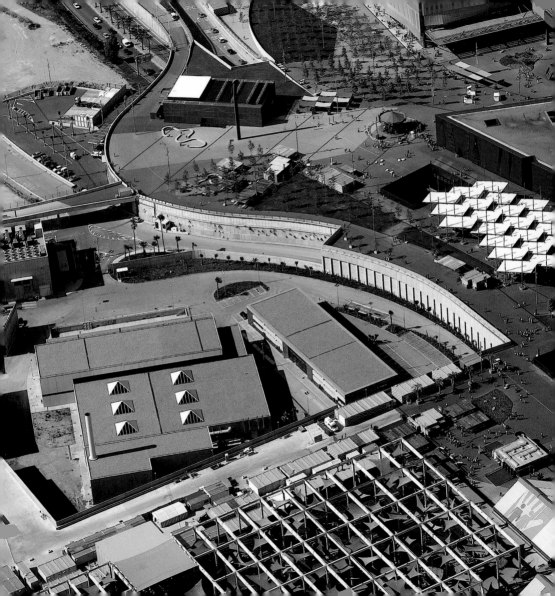

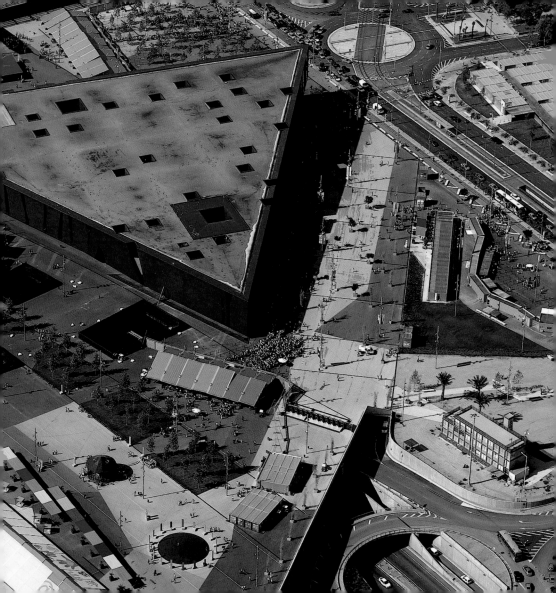

The palimpsest of Barcelona

Joan Barril

Explaining a city to someone who has never seen it is as difficult as describing the sea to people who have always lived inland. Even more so when the sea is unchanging whereas, in contrast, cities are never content with being what they are and want to aspire to more. A European city seen from the air is like the diagram of a tree trunk cut through. In the centre is the origin of the city and, around it, in concentric circles are added other increasingly wider perimeters. A city can be described by its urban layout and for its aerial and distant views. This would be an insufficient description, however, a simple linking of maps of different years that would explain its growth in hectares.

The problem is that hectares do not have souls and the charm of cities lies precisely in the human factor and its stamp.

And this cannot be measured in hectares.

Barcelona has changed as New York has changed and even Venice changes. In some cases the changes in the cities are noticed because they are becoming increasingly bigger. In other cases the changes are a result of absorption. They also change due to collapse, or because of reconstructions. Cities are always improvable in the eyes of the citizens who live in them. Every city, from the moment it is discovered as such, wants to be a complete city. This is a desire that can never be fulfilled, however. Barcelona, for example, could increasingly be thought of as the completed work. The city limits have not been placed by man but by nature: a sometimes kind and sometimes cruel sea is an insuperable limit. Two rivers, one in the north and one in the south, where the industrial areas have taken over the orchards and fields, act as sentries. A mountain range, low in height but deep in meaning is a stimulus for the good sense of not invading it with more buildings. Barcelona is a grand amphitheatre facing the sea. It has the virtue, however, of being an almost complete city.

Growth is a word that, in Barcelona, should be read in a different way, beyond tangible questions. We have a tendency to believe that progress is the equivalent of growth, when in reality progress is the equivalent of balance. The super-cities of the world boast of being the biggest, but this in itself does not bring greater benefit to its people or its visitors. Growth, then, is not an accumulation of data: avenues constructed, streets asphalted, the number of inhabitants, vehicles on the roadways. Growth is a way of feeling full and living with the sensation that every day we learn something new. This is the merit of Barcelona at the beginning of the 21st century. The people of Barcelona, both those who have lived there all their lives and those of just one day, are still surprised by a city that is capable of keeping the stone solidly standing and ensuring that the balconies and streets show off very different colours. This is qualitative growth, that enviable state of being in which we are convinced that we are losing nothing and that, in contrast, we are gaining all. Perhaps Barcelona can no longer be defined as a series of streets that go from the narrow Gothic streets through to the straight angles of Eixample, from the early rural urbanisms to the large avenues of the sun and sea. The city is made up of people who pass by and of corners that preserve the feelings of each one, of balconies that are a setting for life and of lives that go up to the balconies of new perspectives due to the demolition of old houses and of this yellow fence that marks the border between the city of the present and that of the future. The city's vitality depends on this yellow fence that separates work from looking. On one side the machines dig up the reddish earth of the subsoil. On the other side of the fence the future users make sure the work is being done well.

The yellow fence of building work was the true symbol of the city at the end of the 20th century. At that time reinforced concrete was a precious material worthy of adoration. Large spaces were gained where the human silhouette was the measurement of deep things and where people felt more beautiful than they really were. What was then called construct has now taken on other verbs: remodel, adapt, embellish, rehabilitate. The city begins to be built in stratum, one on top of the other. It is the palimpsest city, those ancient manuscripts that revealed writings beneath the writing. The streets where before were raised the steaming chimneys now host the vibrant silence of what have pompously been called "new technologies" without wishing to admit that the only fate of everything new is that it becomes old.

This is one of the great merits of early 21st-century Barcelona. The city rejects newness for newness' sake and returns to the lifelong practices of coexistence. Despite what the apocalyptic thinkers claim, that people do not leave their homes any more, there are few cities that display a street life with all the colours and musical styles like this one. There are two grand invasions that are adapting the city to new times. First of all, Barcelona's conversion into an essential city on the European tourist maps. Secondly, the immigratory movements that have encountered amid the uncertainty of different Spanish governments a good atmosphere to grow and become established. Barcelona's pragmatism has once again enabled it to make necessity a virtue and this phenomenon, which in other cities would have been the detonator of a social tragedy, is turning Barcelona, touch wood, into the melting-pot of new change in the management of the city. The not-far-off day in which an inhabitant from Barcelona with many generations behind them finds that the local policeman giving them a fine is someone who was born in Ecuador, or that the local bank manager who gives them a loan is an economist called Hassan, will be the day in which the city has founded itself once again.

I recall a sentence from my early childhood. My grandmother sometimes took me for a walk along the Diagonal Avenue, beyond the Francesc Macià roundabout. She had lived in a type of country house in the middle of fields. In reality my grandmother used me to attend the spectacle of the city's urbanisation. When we returned home my grandmother said the definitive sentence: "How everything's changed! You wouldn't recognise it!" It is this permanent state of surprise that makes Barcelona the jewel and display cabinet, screenplay and stage, actress and audience, all at the same time. The city's permanent change comes from the sky and the subsoil. Perspectives are recovered and new ones created. And when we say we would not recognise the city we are admitting that perhaps we citizens should make a serious effort to recognise ourselves.

And the final question. We are talking about Barcelona and we are making Barcelona a feminine noun in Spanish. A campaign by the City Council in the 1990s promoting the rehabilitation of façades of buildings carried the slogan: "Make yourself beautiful Barcelona", (*ponte guapa* in Spanish, the feminine adjective). One talks of "old Madrid" (*viejo Madrid*, the masculine adjective). Barcelona is female, however, a woman, mother, sister, girlfriend, she is feminine and sheltering, heroine-like when necessary and sad when she wants to become melancholy. When Barcelona mobilises, its people respond, whether it is for a pacifist demonstration or a Brazilian samba show. The streets are for filling up with people. And the ultimate reason behind this success in mobilising is in reasserting themselves as members of this great tribe of tribes who have brought their lives here to tell them and to be listened to. Barcelona is now beautiful, but to this urban beauty should also be added, little by little, a subtle beauty of intelligence: the discrete intelligence that only long-distance lovers know how to display.

Barco

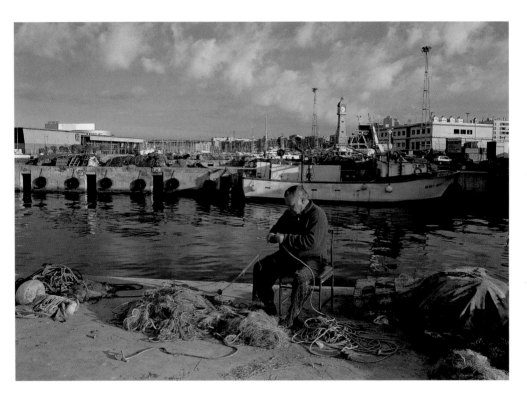

Fishermen's port

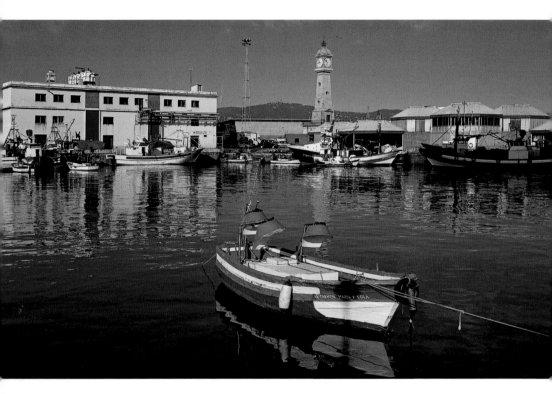

The port of Barcelona is both exit and entrance. In the east are all the knots and the lighthouses of the Mediterranean, the smell of fish and the enigma of the winds. In the west are the mountains that act as a pedestal for the clouds. In the centre, a city that has grown between the canticle of the waves on the sand and the air that makes pine trees sing on all its hills.

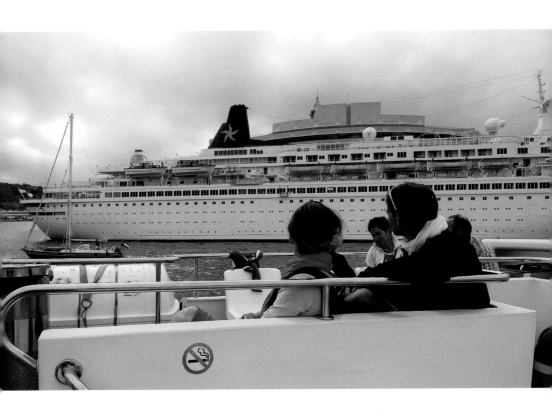

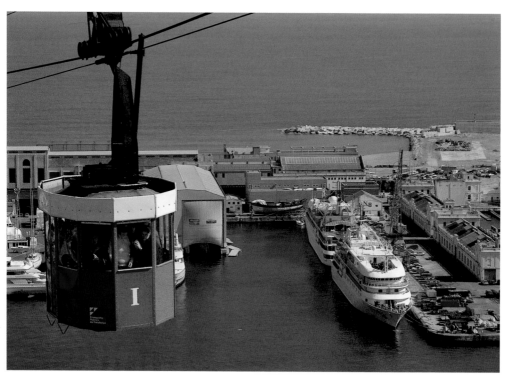

Montjuïc Cable Car

World Trade Center, 1988-1998. Henry Cobb

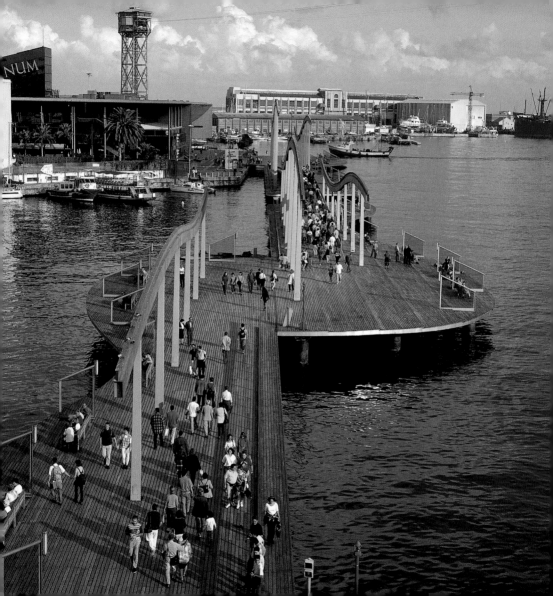

Rambla de Mar and Maremàgnum, 1990-1995. Albert Viaplana

Rambla de Mar→

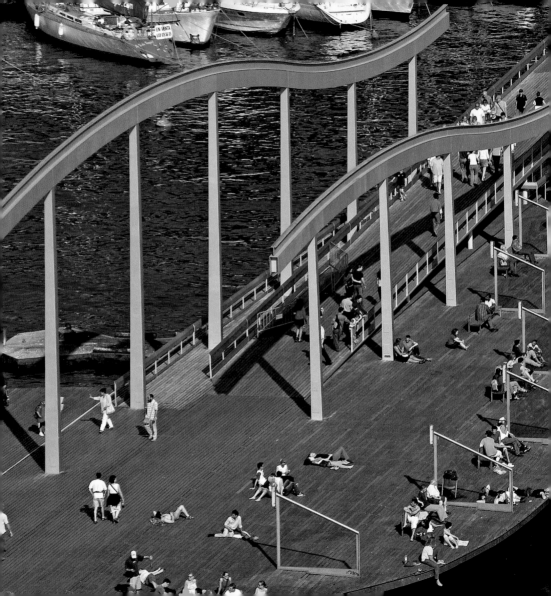

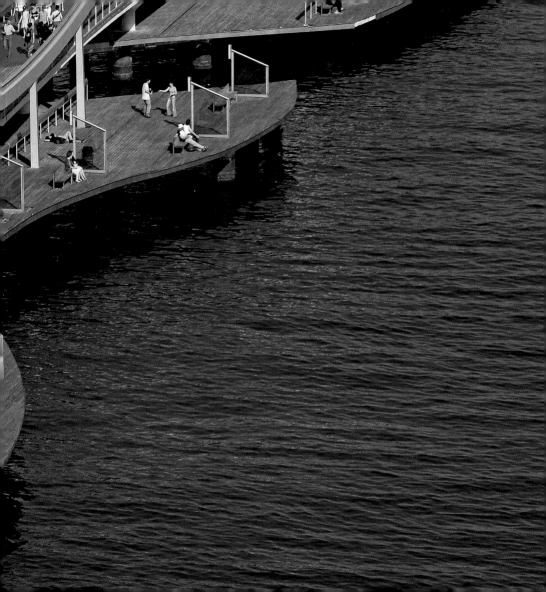

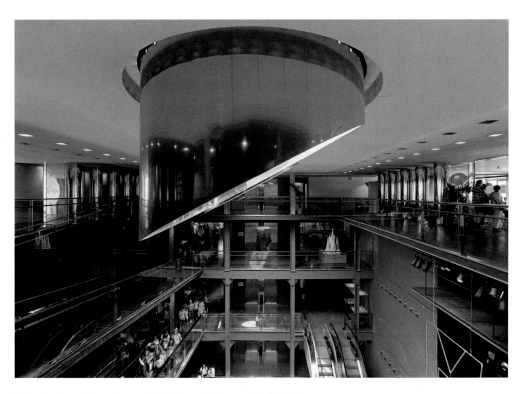

Palau de Mar, old warehouses of the Compañía General de Depósitos, 1874-1879. Elies Rogent. Home of the History of Catalonia Museum

The Aquarium

Monument dedicated to Christofer Columbus. 1888.
Gaietà Buïgas and Rafael Atché

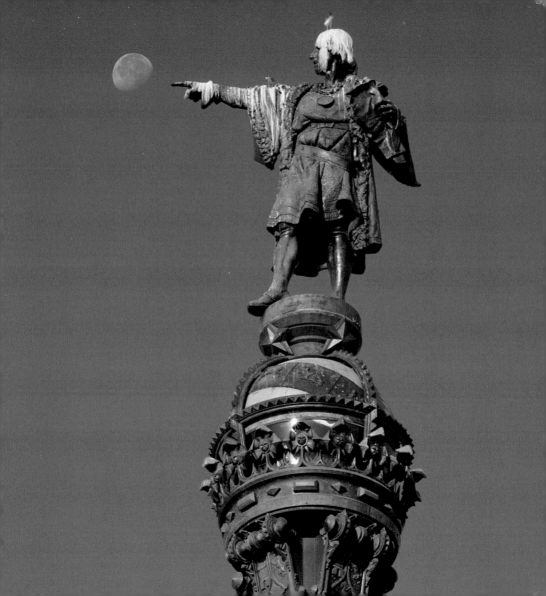

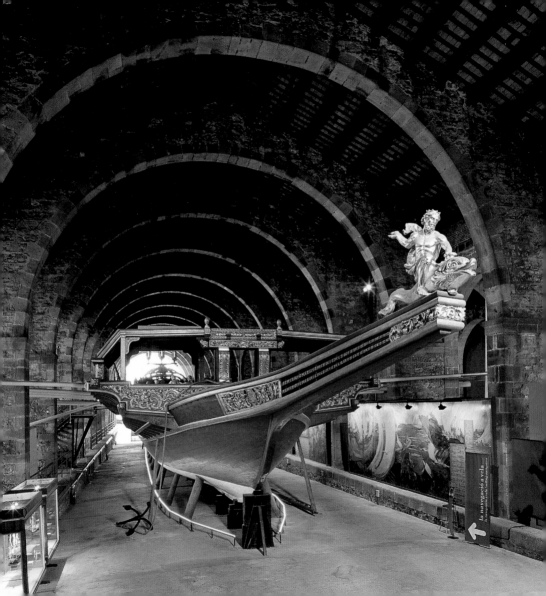

la navegació a vela

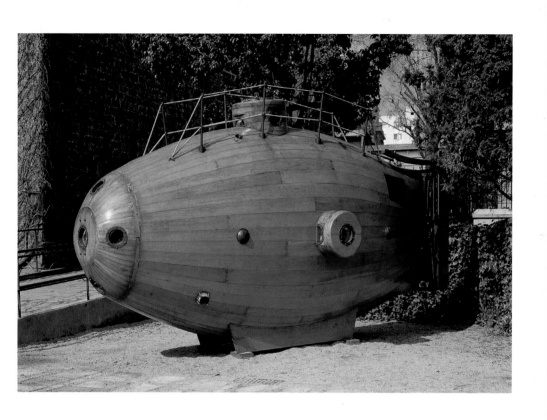

Royal Shipyards of Barcelona, 14th century.
Home of the Maritime Museum

Barceloneta Beach →

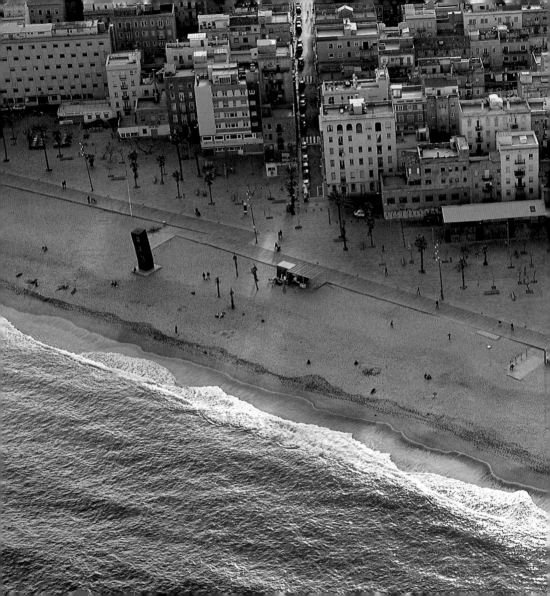

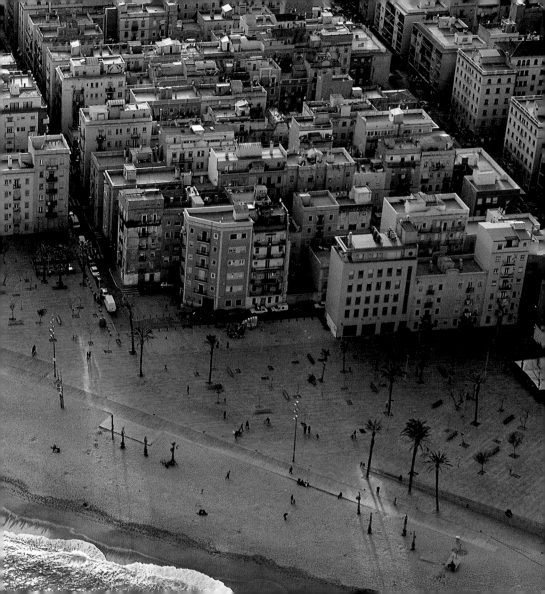

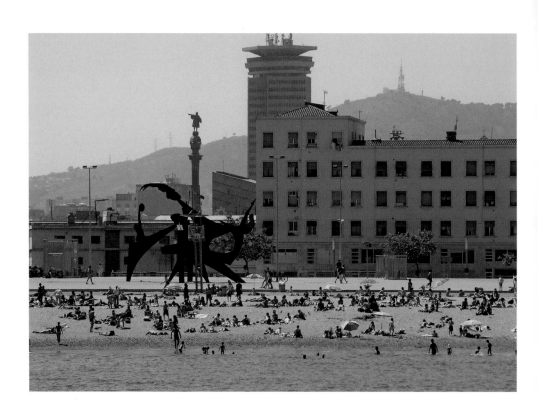

Barceloneta and Mar Bella beaches

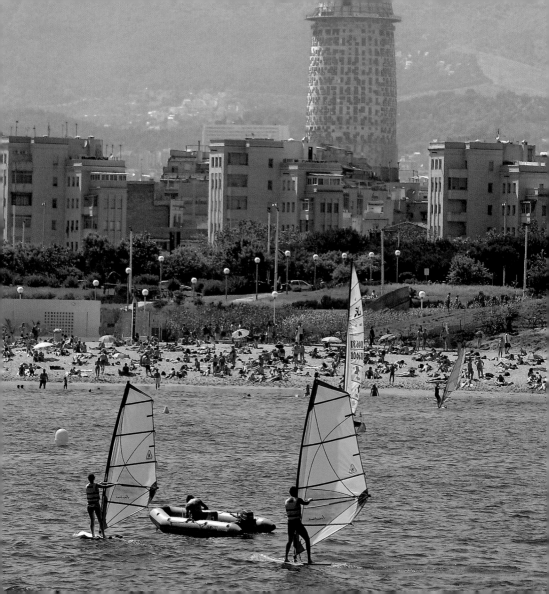

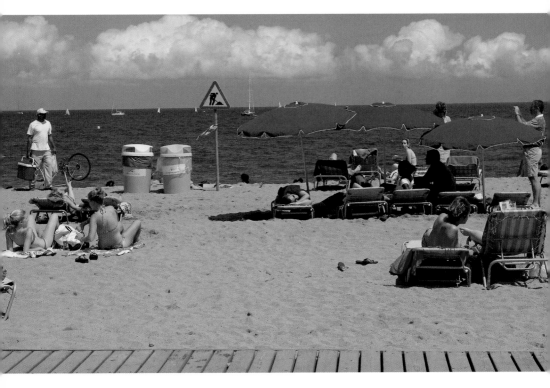

If we look close-up at the sand on the beach with a magnifying glass we will see fragments of quartz, felspar and the blackness of the mica, which are the decomposed parts of this grand universal stone called granite.

If we move away from the sand, however, we will see other substances that are not necessarily mineral: skin, sun lotion, lack of sleep, fleeting love and a faraway vestige of the saurians in the sun which during the early days of evolution we must have been.

Every year, the beaches of Barcelona become the setting for the Festival of the Sky: kites, hot air balloons and aircraft ride the winds →

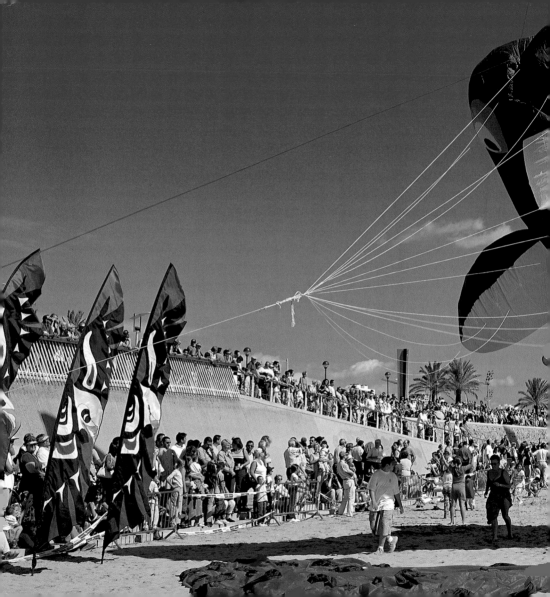

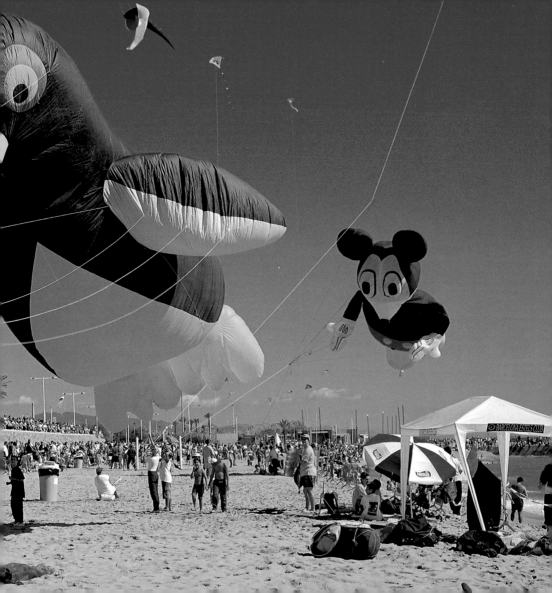

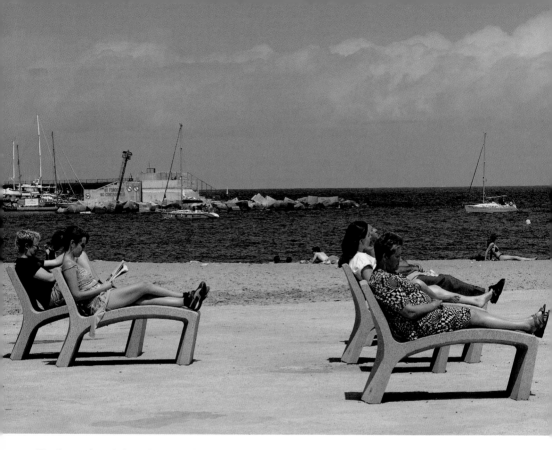

The three-coloured city makes us seek out a fourth. On the upper section the sky blue of the sky. In the centre, the greenish blue of an ancient sea that is the drawing board for those who illustrate the wind. Below, as if the earth was nothing more than the waste of all the planet's erosions, a toasted and granulated surface that attracts light and heat. A people of sun-lovers who surrender to the vibrant peace of the sun's rays. This is not about towels but rather chairs, as if the people of Barcelona were conversing with the heavenly bodies and allowed themselves to be possessed by the same feelings that made the first saurian beings progress. Like thinking animals, before the sun and over the three colours of the coastline, people leave thought behind and allow themselves to be impregnated by the great energy of the universe.

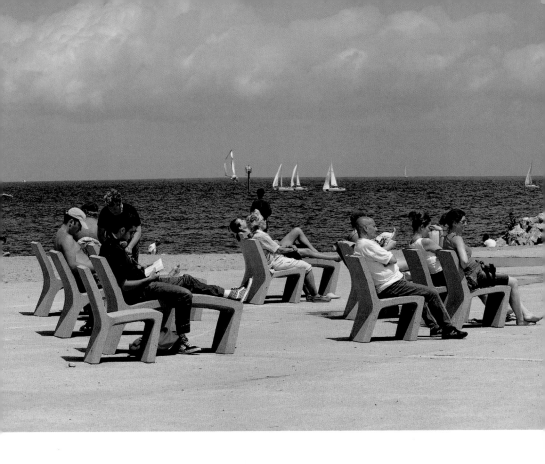

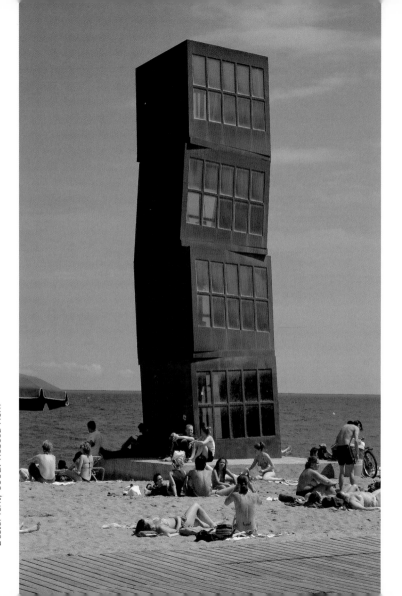

L'estel ferit, 1992. Rebeca Horn

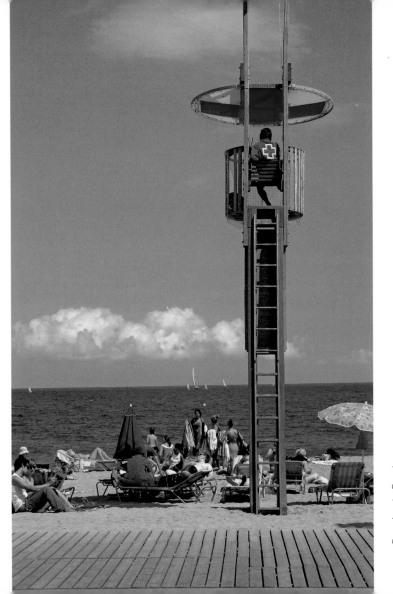

Barceloneta Beach

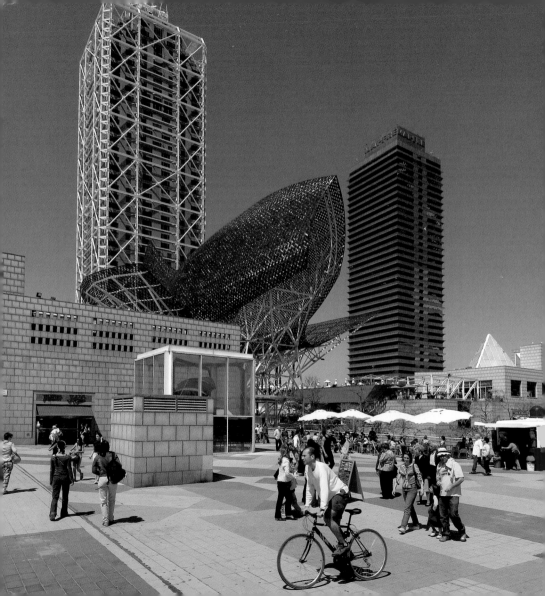

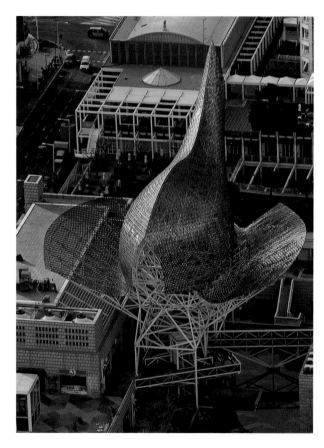

Peix, 1992. Frank Gehry

The towers of the Olympic Port are the threshold
separating the Barcelona of work, traffic and noise
from the Barcelona of leisure, strolling and sunlight.

Olympic Port →

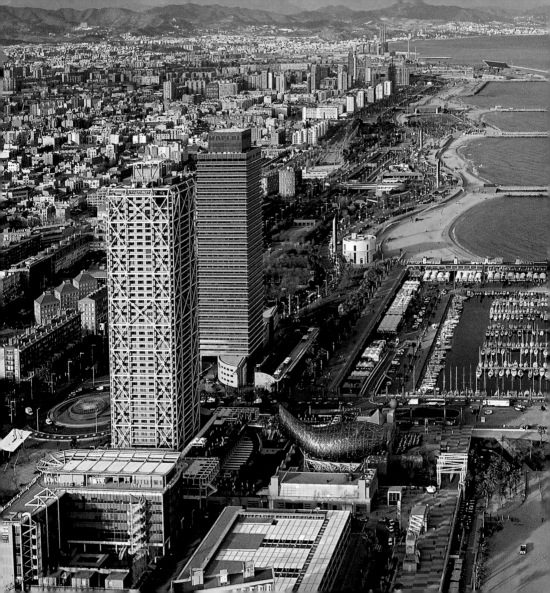

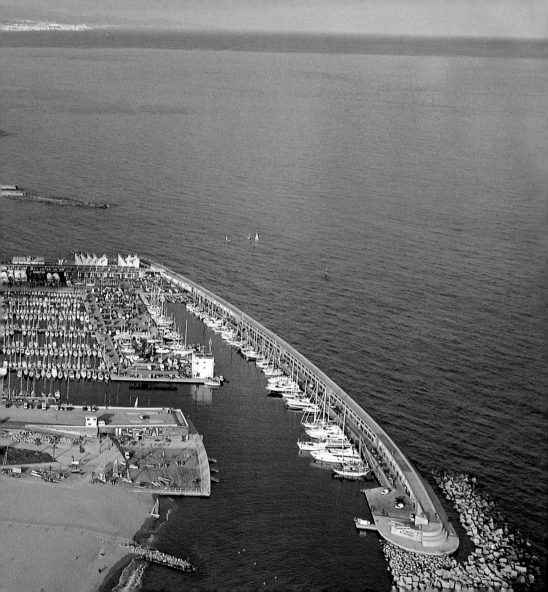

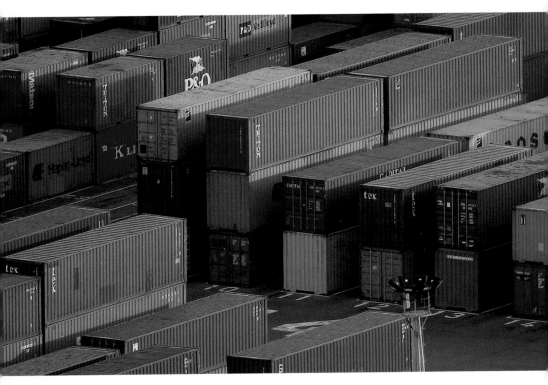

The Mediterranean has provided food, salt, wine and languages. In the past life arrived in the wicker baskets or tangled up in the sewn and unsewn nets like the cloak of Penelope. Today life is invisible and commercial progress is hidden within the metallic and multicoloured prisms. The container is the measurement of all maritime goods. The continent is no longer important. Inside these enormous metal boxes are all the treasures of all the shores. Not even human arms sweat when it is moved from the land to the hold. The world is round because a square object goes from port to port until returning to the spot it started off from. Only the fish are the suspension points of an old sea that gives way to businesses that are floated more often than the boats that carry them.

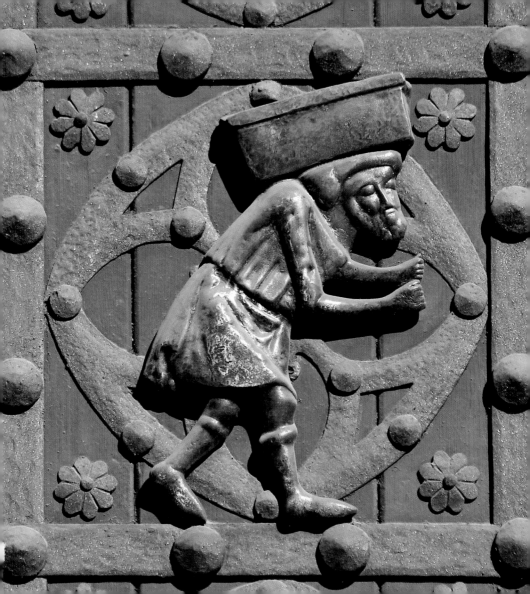

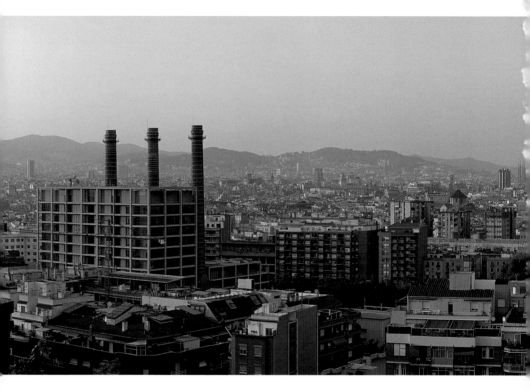

On the metal figures on the doors of Santa María del Mar, the true metal is in the muscles of those who built the city with the strength in their arms. The history of cities is sometimes explained from the lives and feats of its gentlemen, armies and princes, of its battles and festivals. Perhaps the time has come, then, to look at cities from the point of view of everyday folk. Let us pick up a magnifying glass and

a panoramic engraving of the city we want to discover through time. Hold the lens of the magnifying glass over any figure, the one furthest from the centre of the image. Then try to imagine what that person was called and, if they are carrying a bundle or a chest, what they had inside it.What language did they speak? What wage did they receive for their day's work and who was waiting for them at

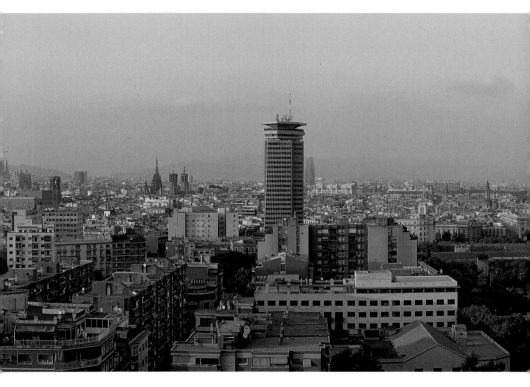

home? What illnesses did they suffer from and what happy events gave them hope? In these silhouettes of workers is found the tale of tenacity. People who dived into the waters of the port with or without a boat and who dragged the parcels back to the shore. In those days they loaded them on their backs and left them at the door of the market. Walking along the narrow streets of the city that grew we would see around it the scaffolding of the big cathedrals and the engineering of the fresh water channels. We would hear the pealing of the bells or we would defeat the cold in the polychromed glass or wrought iron forges from which would later come the cannonballs for defence or attack. Cities are not empty streets or closed houses.Without citizens there are no cities. From the efforts of these people comes the city of today.

Porters on the doors of Santa Maria del Mar →

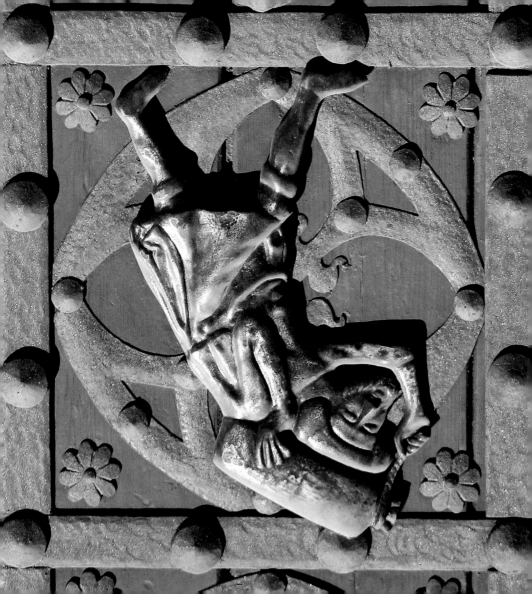

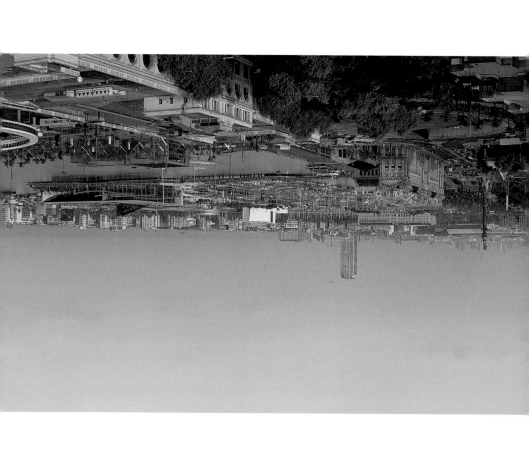

There was once a time when the bells were the translation of time into sound. Today time is the frenetic translation of life. A bell tower can no longer replace a digital watch with precision, but it can provide us with a measurement of the state of the soul. A bell tower reminds us of the nails with which God and his representatives have tried to fix the city to the earth to avoid it escaping from its eyeful

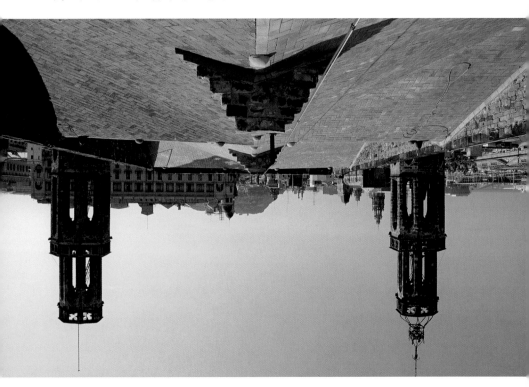

watch. From the inside, the stone trunks of the apse show us the light that is filtered through all the chinks in the forest. In Santa Maria del Mar the roses are made of glass but they do not prick. And the swords of the warriors no longer support the kingdom of men but rather the vaulting of the houses of the soul.

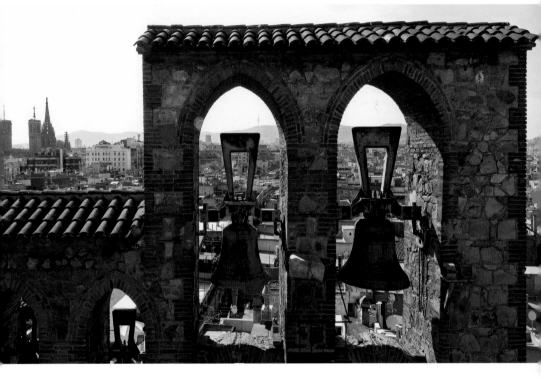

Roof and bell tower of the church of Santa Maria del Mar, 14th century

Church of Santa Maria del Mar. Apse →
Rose window and keystone →→

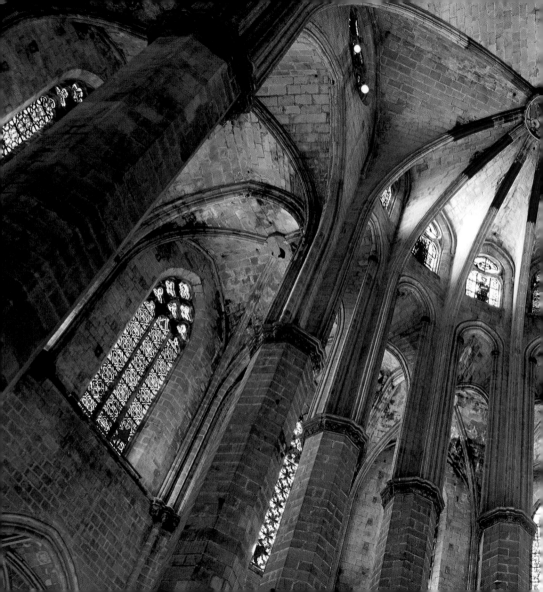

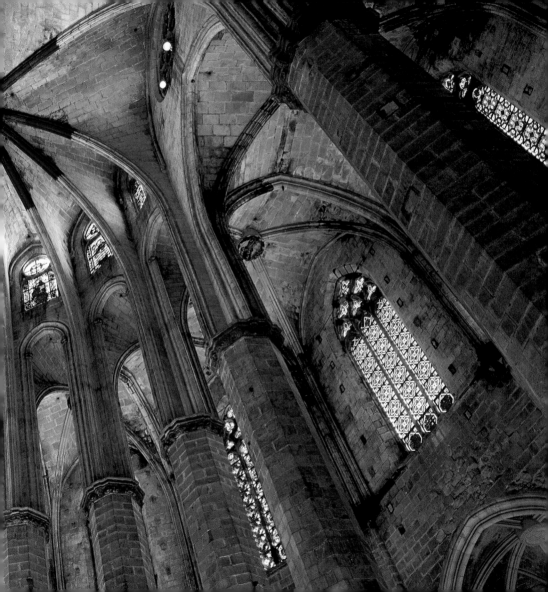

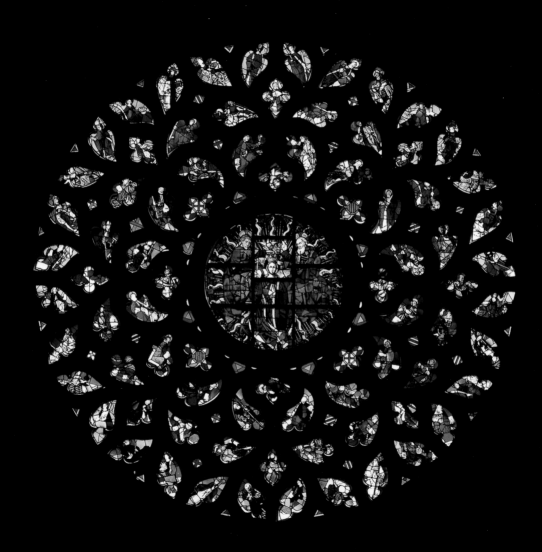

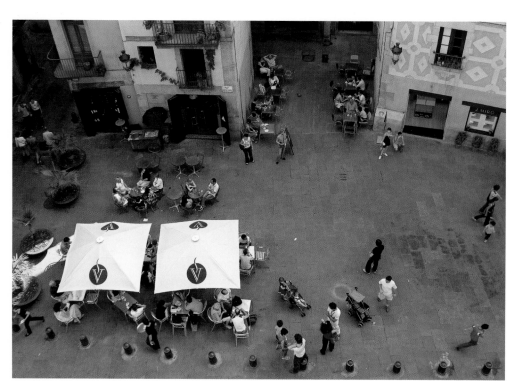

Plaça de Santa Maria

Carrer de les Caputxes

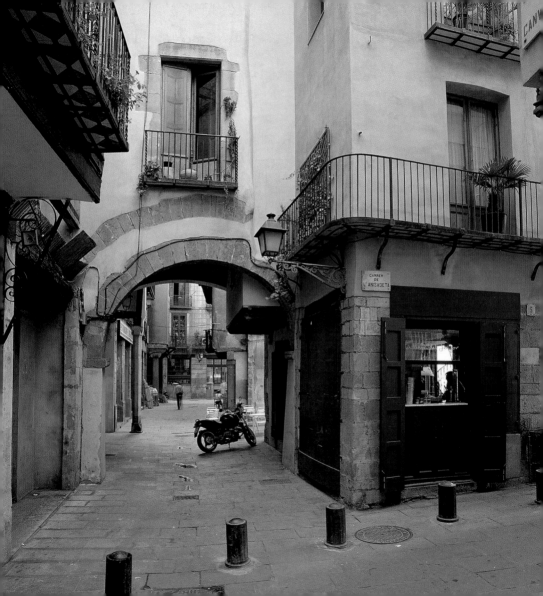

Born, 1992. Jaume Plensa

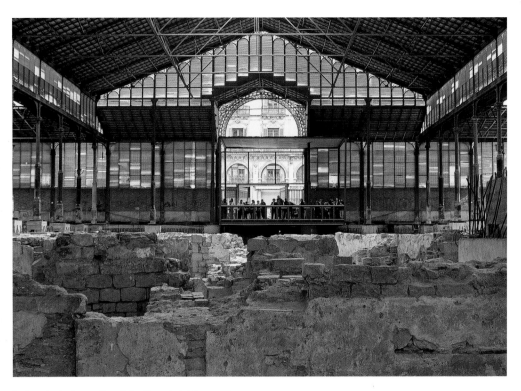

Archaeological complex of the Mercat del Born with
remains of the district of Ribera destroyed during the
siege by the troops of Philip V (1714-1716)

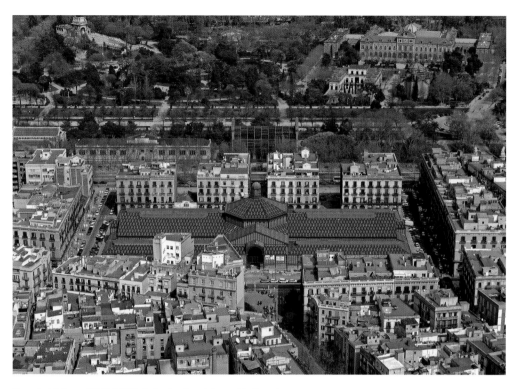

Mercat del Born, 1874-1876. J. Fontserè and Josep M. Cornet

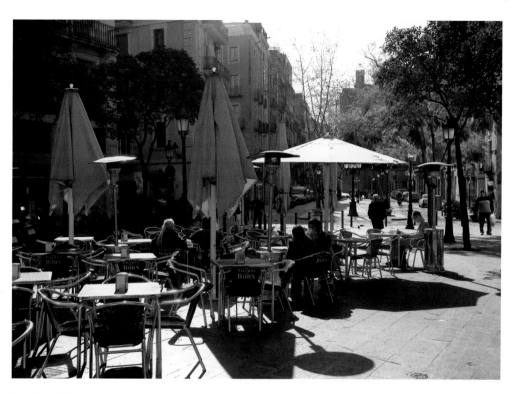

Passeig del Born

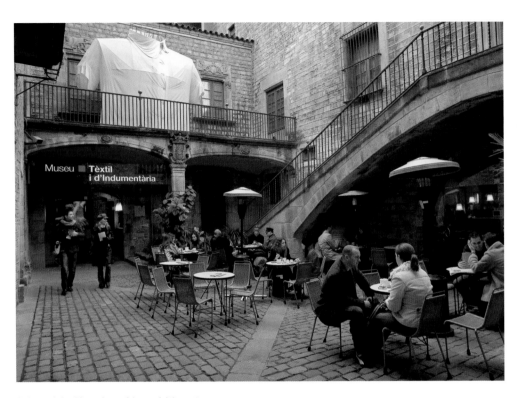

Palace of the Marquises of Lyon, 14th century.
Home of the Textile and Clothing Museum, Carrer de Montcada, 12-14

Carrer de la Vidrieria

Berenguer d'Aguilar Palace, 15th century.
Home of the Picasso Museum, Carrer de Montcada, 15-19

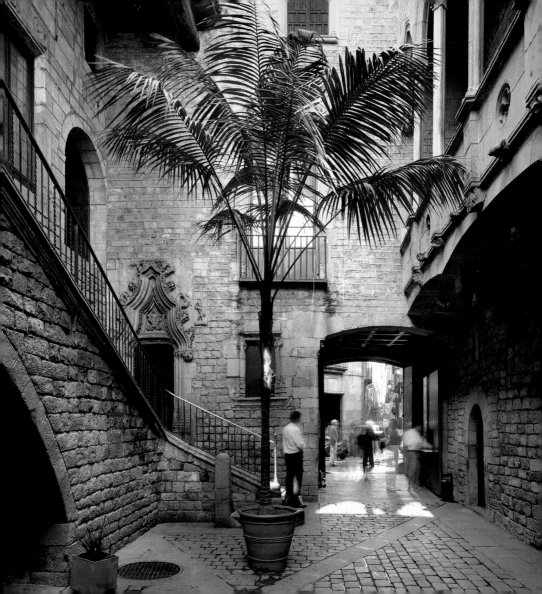

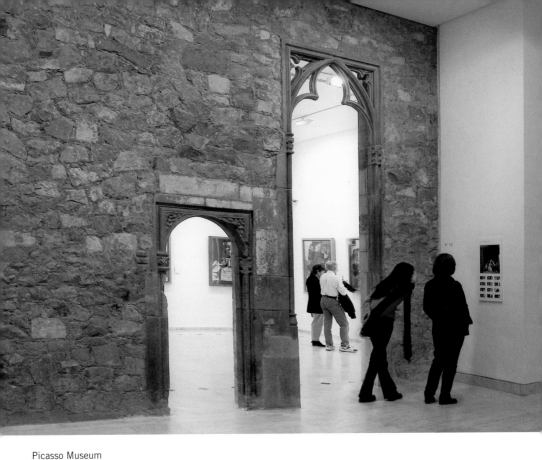

Picasso Museum

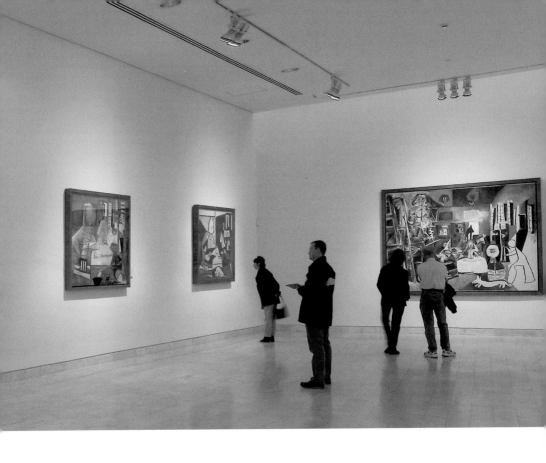

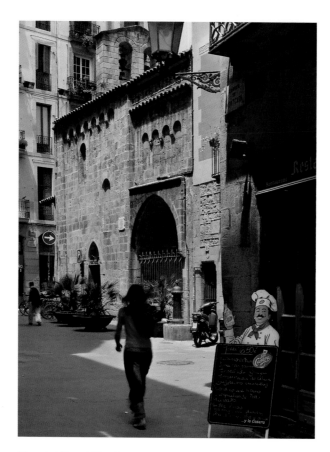

Chapel of Bernat Marcús

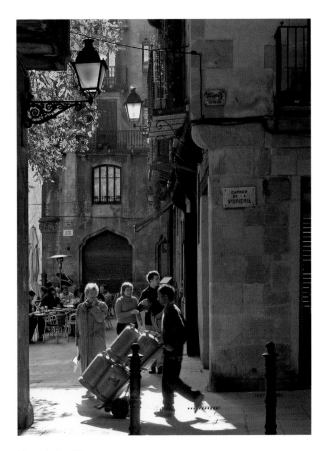

Plaça de les Olles

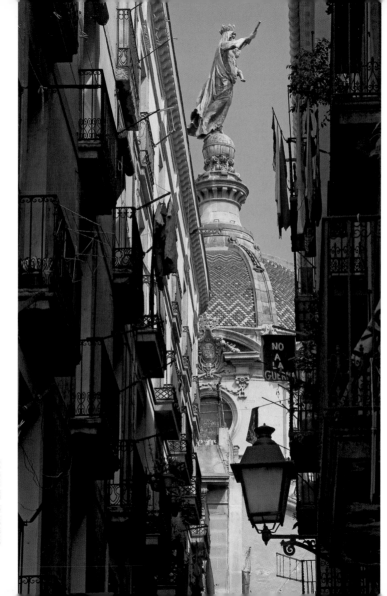

Church of La Mercè

Fountain of Catalan genius, 1856. Faust Baratta i Rossi, in the Pla de Palau

Streets as clearly defined as a beam of light, like a groove of sunlight that opens up between palaces. Two angles. The angle of the façades over the pavement. The houses have grown up from the earth with vertical precision. The rounded angles due to use by so many people who have rubbed their bodies against the walls protecting themselves from the rain perhaps, from the darkness or from their enemies. The other high-up angle, where the ivies stop because the sky rejects them. Above the rooftops a new city floats over the old one. Now and then Gothic pinnacles appear, or abandoned dovecots, calm sunshades and the hanging

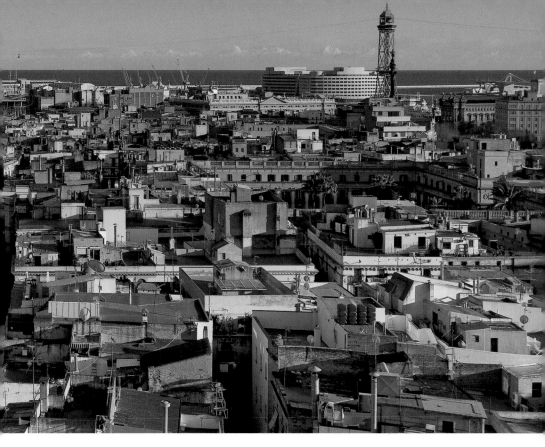

clothes of a district that holds the secret of flying in its sheets. The nooks and crannies of every corner shelter musicians and tradesmen. The corners of the eaves and gargoyles are the worlds of small stories of cats, birds and insignificant lives. And it is in these insignificant lives where cities become big.

Ciutat Vella →

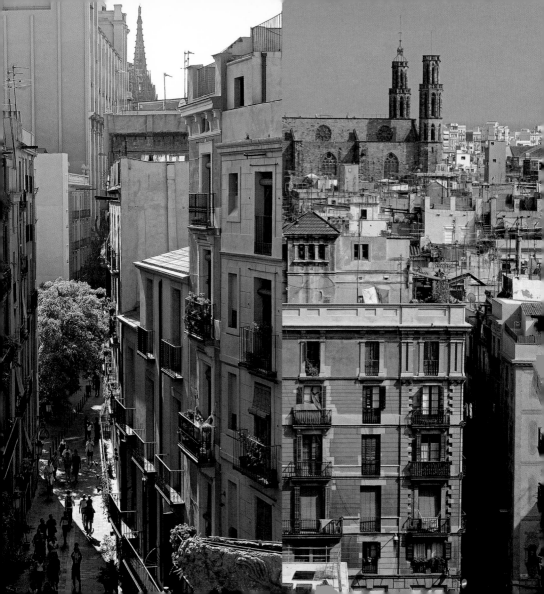

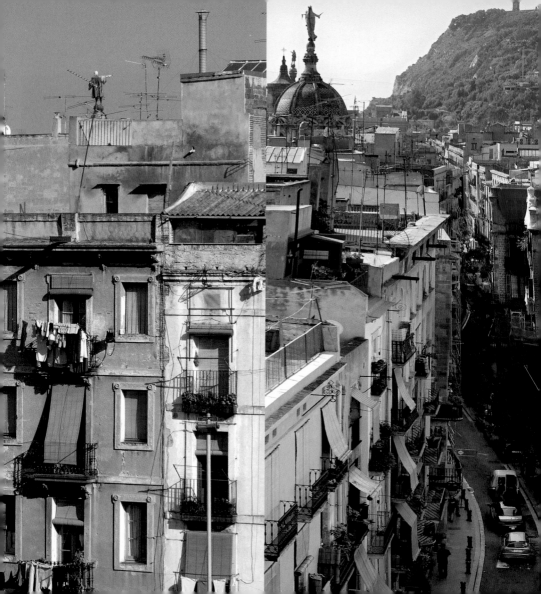

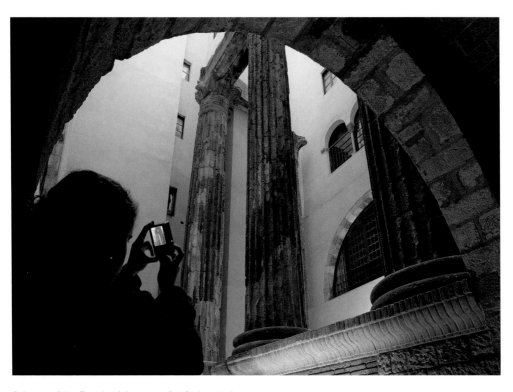

Columns of the Temple of Augustus, 1st-2nd centuries.
Home of the Catalan Excursionists Centre, Carrer del Paradís, 10

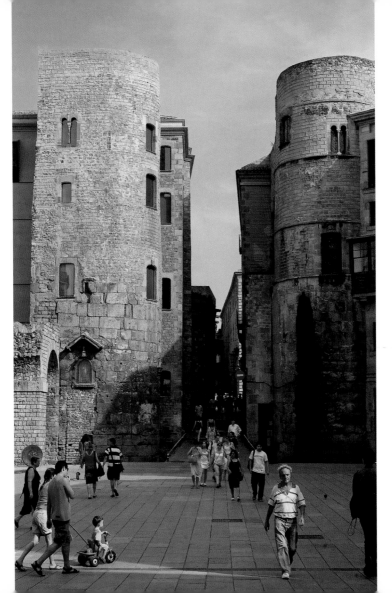

Praetorian Gateway of the Roman wall, 3rd-4th centuries, in the Plaça Nova

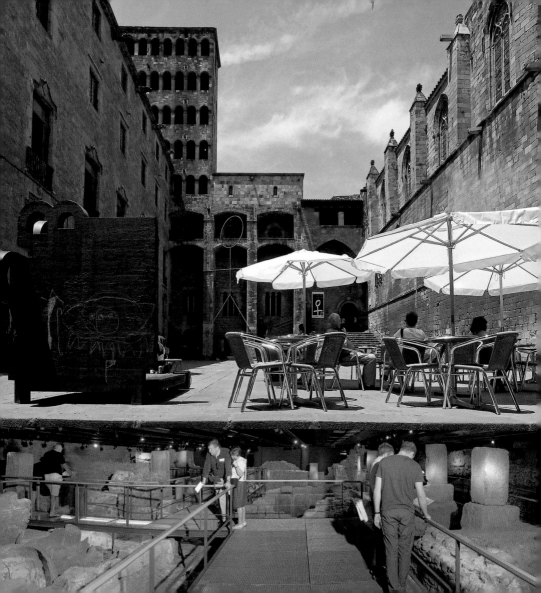

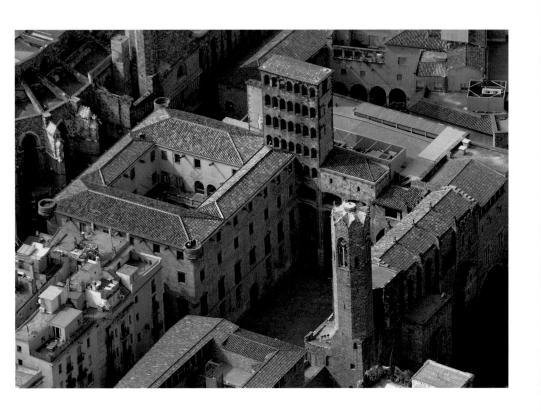

Plaça del Rei, with the Main Royal Palace, the Palace of the Viceroys, the Chapel of Saint Ágatha and the Casa Padellàs, home of the MHCB (Museum of the History of the City). In the basement are preserved Roman and Paleochristian archaeological remains

Main Royal Palace. Tinell Room, 14th century, Guillem Carbonell →

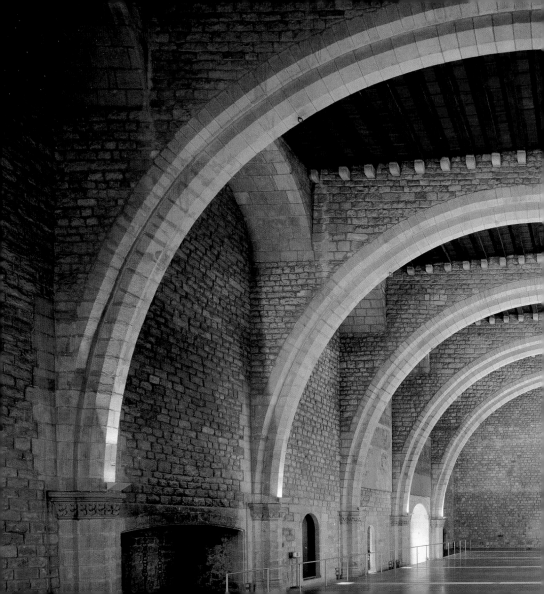

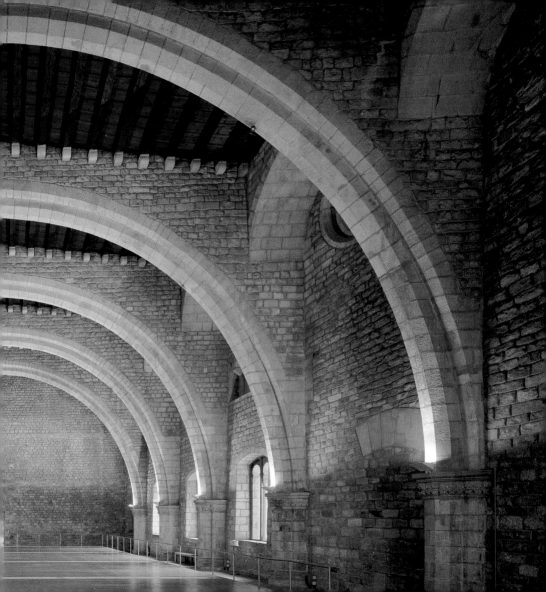

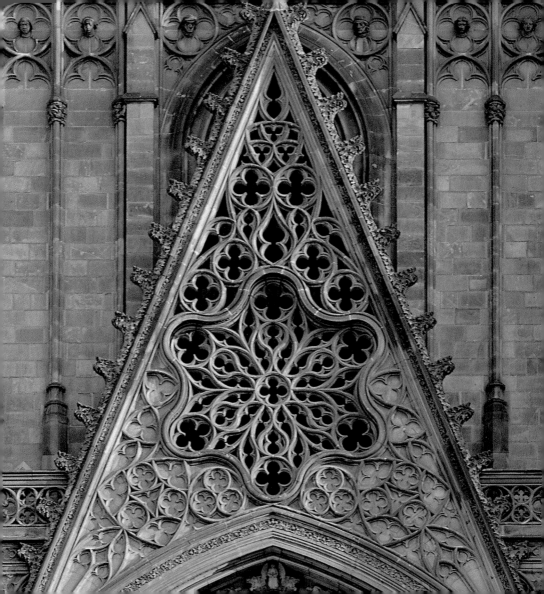

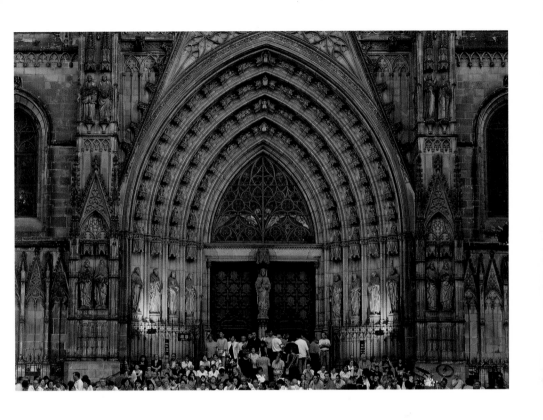

Barcelona Cathedral, 13th-15th centuries.
Main façade, 1887-1913, Josep Oriol Mestres and August Font

Barri Gòtic →

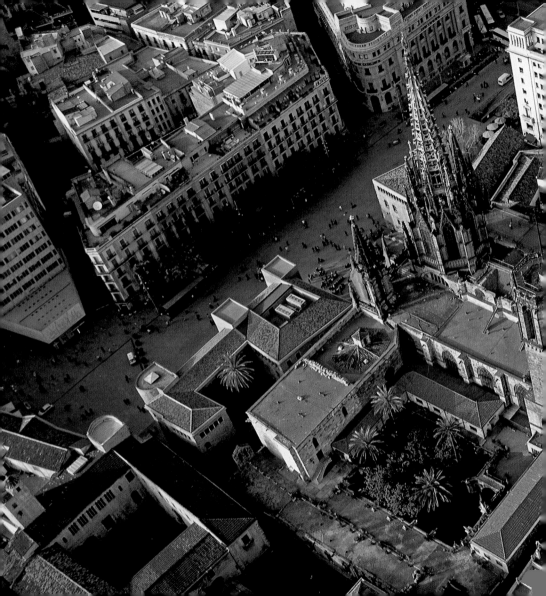

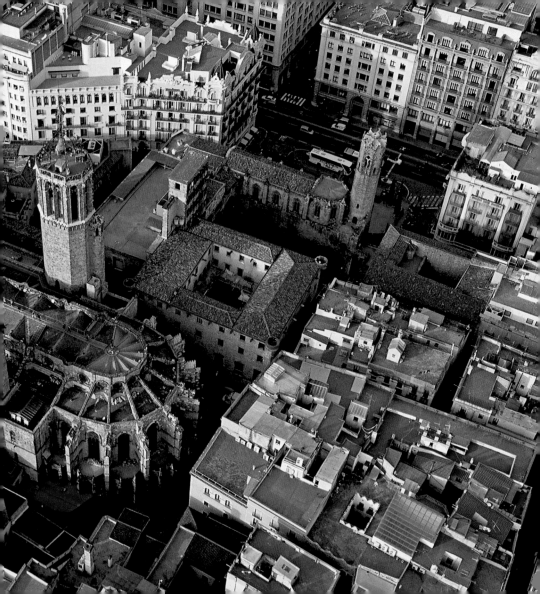

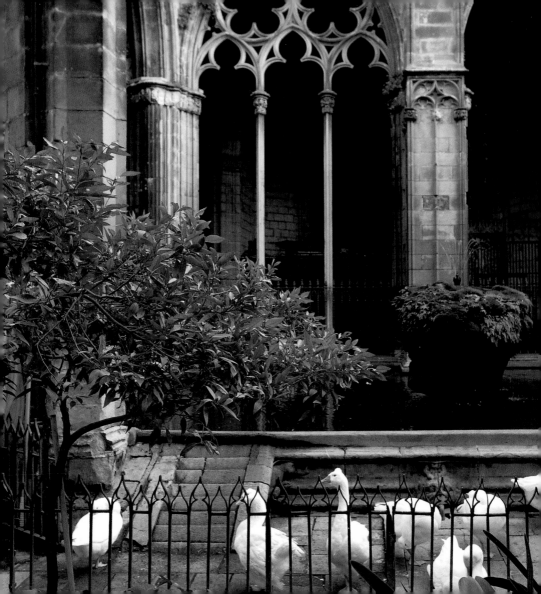

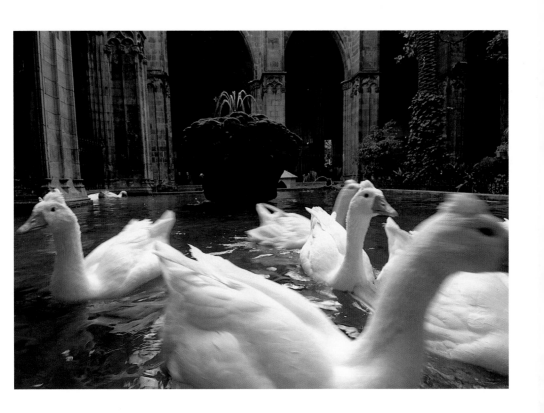

Cloister of the Cathedral 1382-1448

Gothic images of Ciutat Vella →

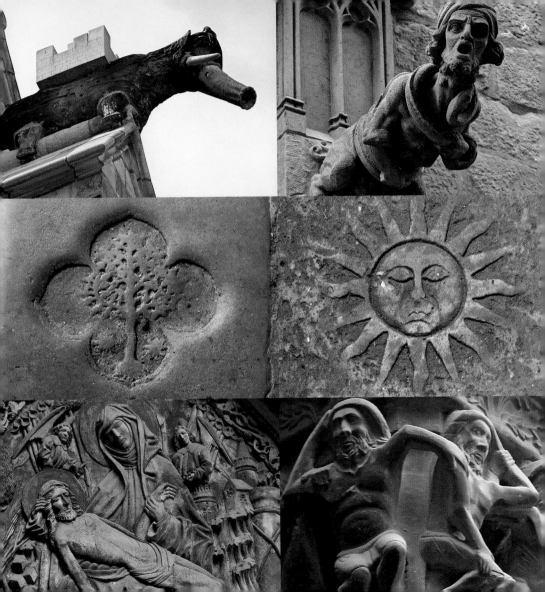

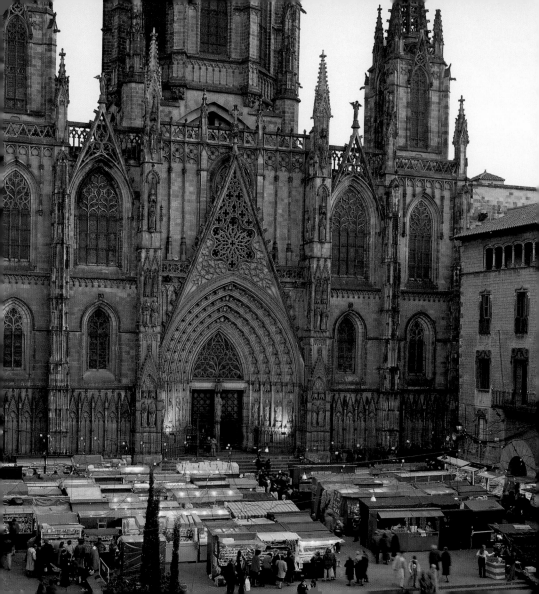

Nativity scene stand in the Christmas Fair of Saint Lucy

Plaça de Sant Just

Sardana dancing in the Avinguda de la Catedral

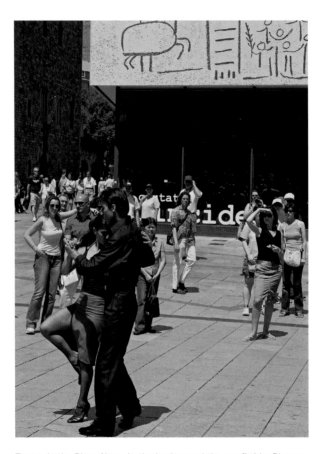

Tangos in the Plaça Nova. In the background the sgrafitti by Picasso
that adorns the headquarters of the COAC (The Official College of
Architects of Catalonia)

Barcino, 1995.
Joan Brossa

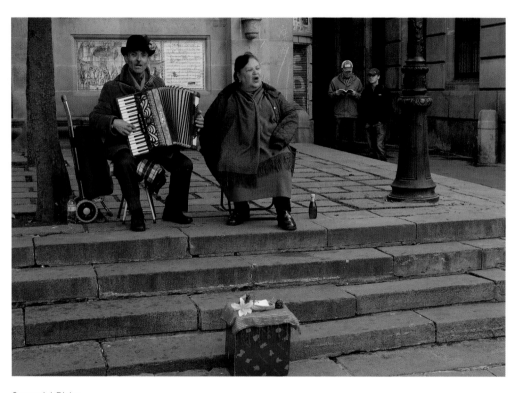

Carrer del Bisbe

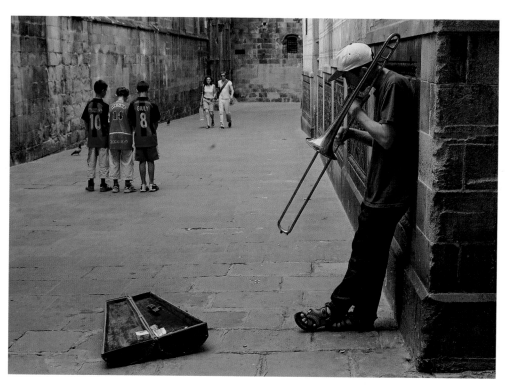

Carrer de la Pietat

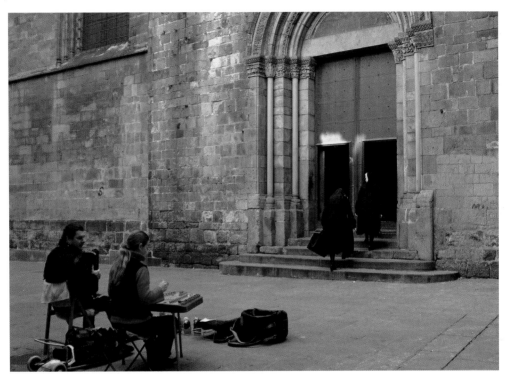

Cathedral. Portal of the chapel of Saint Lucy, 13th century

Carrer del Bisbe

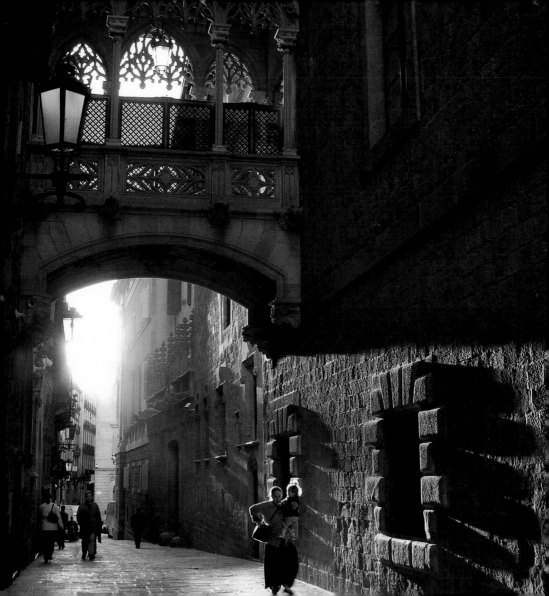

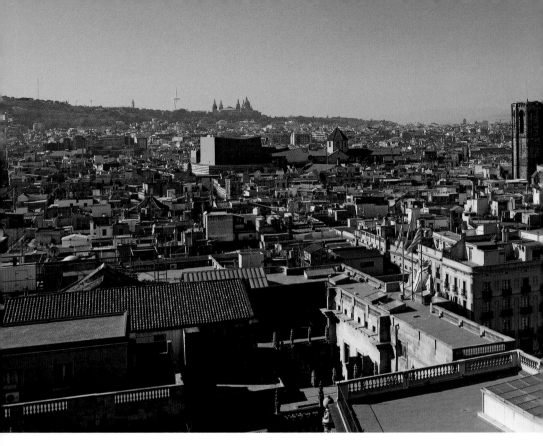

Plaça Sant Jaume, headquarters of the City Council and the Catalan Autonomous Government (Generalitat).

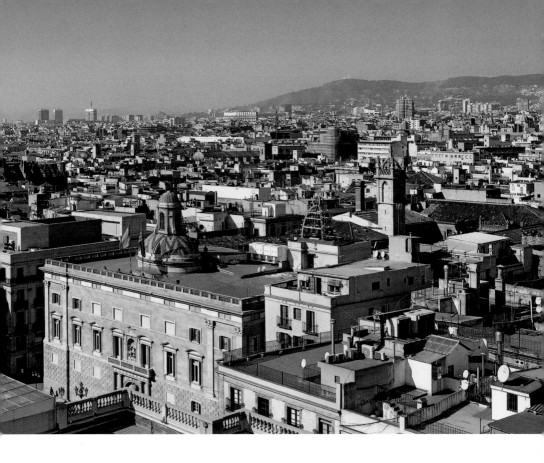

L'ou com balla (the dancing egg) is a unique tradition in Barcelona that consists of making an egg dance on the fountains of cloisters, courtyards and gardens on the day of Corpus Christi.

Casa de L'Ardiaca, 12th-13th centuries, home of the Historical Archive of the City

Carrer dels Banys Nous

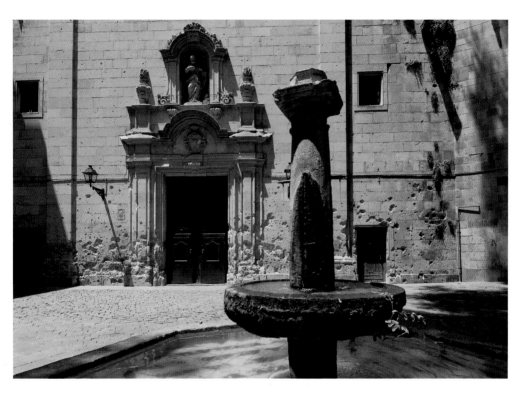

The Plaça Sant Felip Neri has just two sounds that belong to it directly: the murmur of the water from the fountain and the shouting of the children entering and leaving school. If we approach the walls we will hear the racket of the bombs of a Civil War that still bleeds through the cracks in the stones of the church.

Church of Santa Maria del Pi, 14th century →
Ciutat Vella, the Call, the Jewish quarter→→

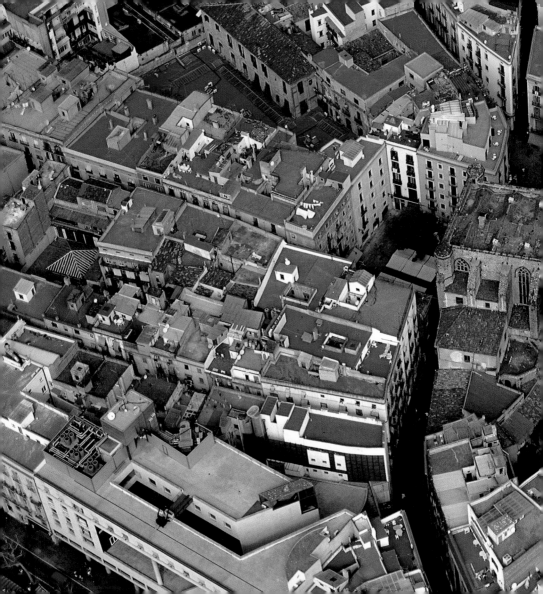

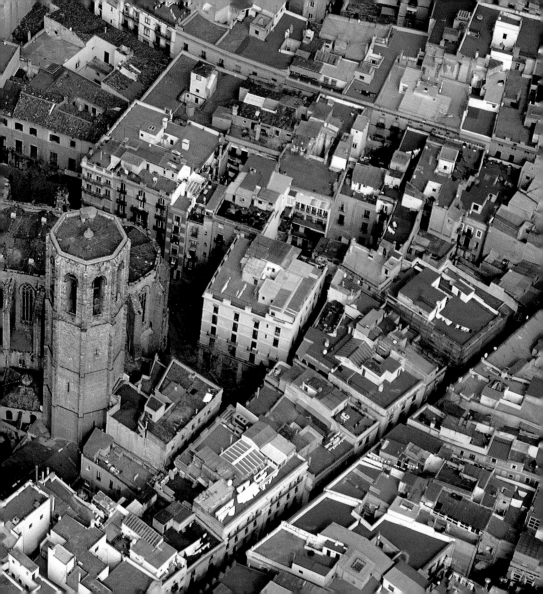

Plaça de Sant Josep Oriol in Ciutat Vella

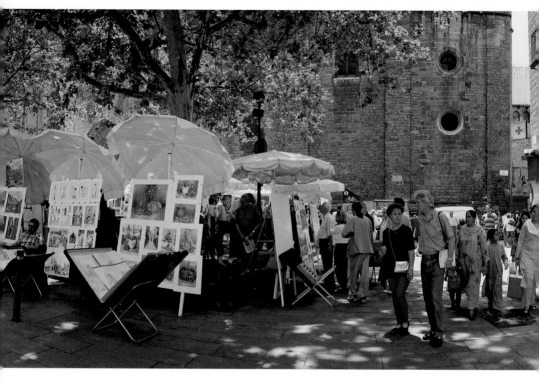

The streets of old Barcelona have the straight beam of light. In these narrow streets you always see a strip of sky that just about shows us the sunlight. The squares in the Ciutat Vella district are really great deposits of sun where the citizens go each day in search of a ration to take home with them and make the canary sing or for drying their hanging clothes. These squares are not meant to be crossed quickly or running. When the walker reaches one of these sunny squares they stop like navigators before crossing the ocean. People walk slowly and look for any pretext to sit down and sense living nature within a superb setting.

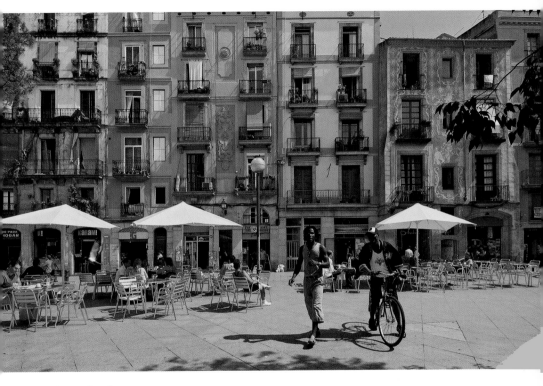

Plaça de George Orwell

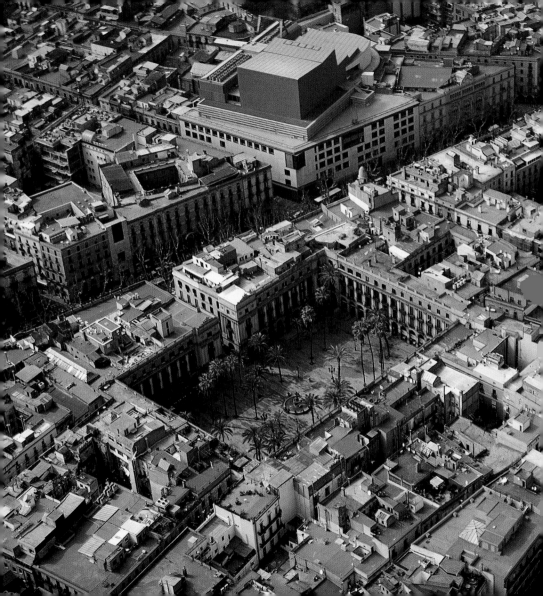

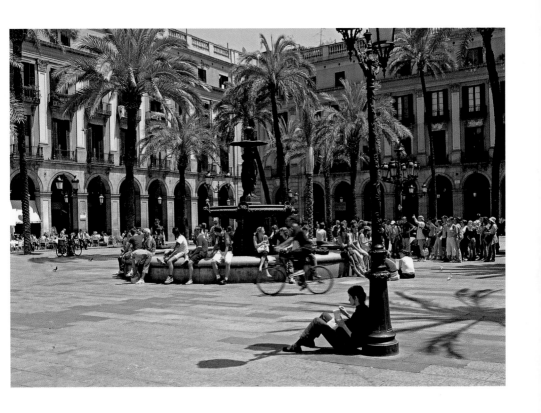

Plaça Reial

La Rambla →

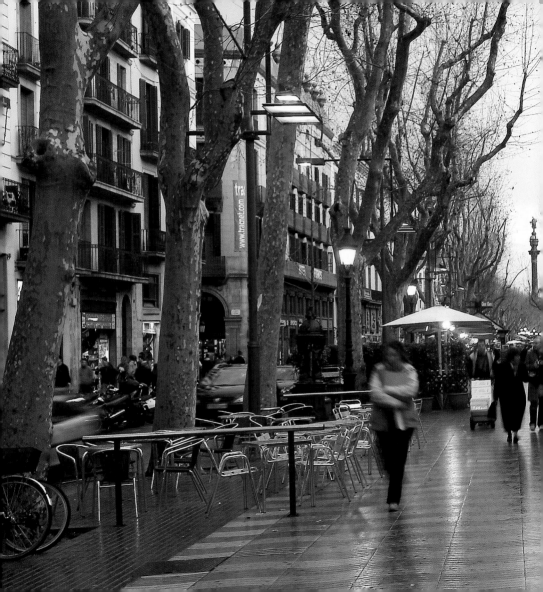

There are not that many differences between the zoo and the theatre. Some look and others are there to know how to be looked at. Some sit down and see life pass by. Others pass by and look at those seated. The Rambla of Barcelona is shop window and terrarium alike, a world without frontiers where everyone is seen as a reflection.

If the world were to disappear beneath a lethal explosion and only a few thousand people remained alive on the planet, the reconstruction of civilisation would take the form of the Rambla of Barcelona. The Rambla is the kingdom of anonymity, a street where no kiss is furtive and where the street musician has as much dignity as

the banker from the grand offices. In the Rambla you can breathe in the smell of the vegetables from the market and the perfume of the lady from the Liceu theatre. From the mixture of so much contrast arises a uniform spiritual matter. Art goes down into the street and life becomes art. The Rambla is never still. It is in reality the collective conscience. The great impulses of Barcelona are going to be written in the great school of the Rambla, where the water from a fountain tastes like an elixir of citizenry that turns all the colours into a restless pigment that we could describe as the colour Rambla and that nobody has yet been able to export to other parts of the world.

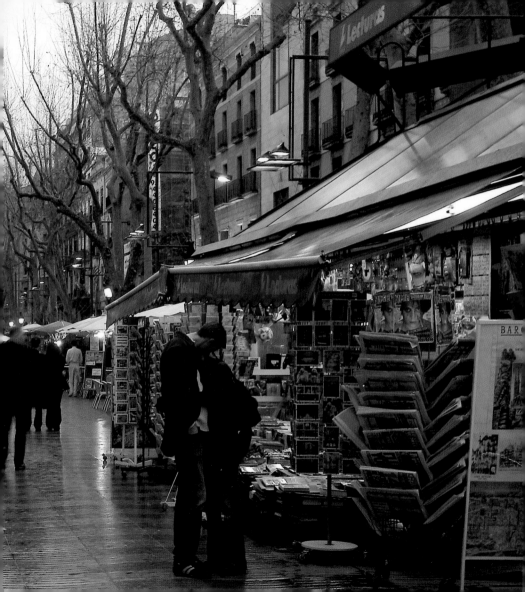

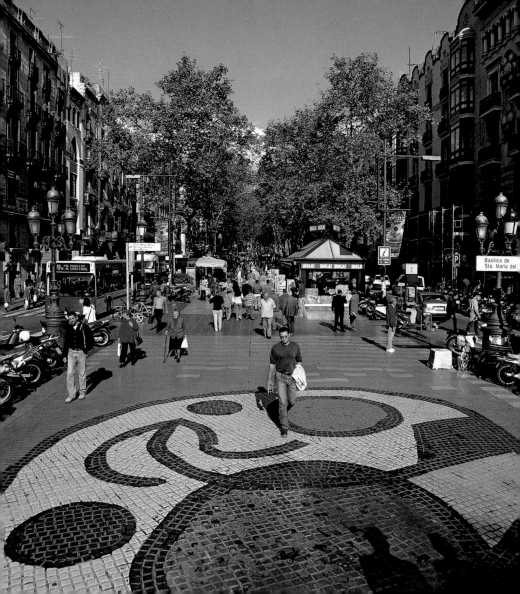

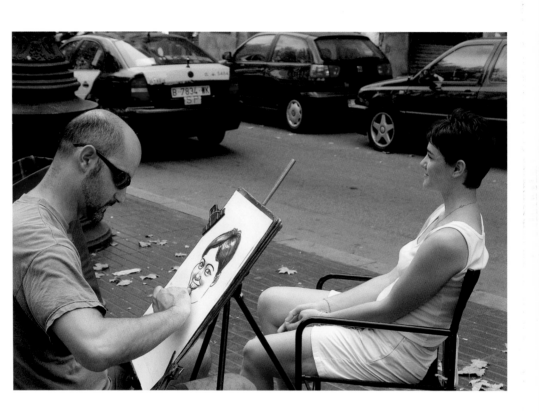

The mosaic by Joan Miró in the Pla de la Boqueria is like
a multicoloured heart that beats beneath the feet of the
passers-by and residents of La Rambla

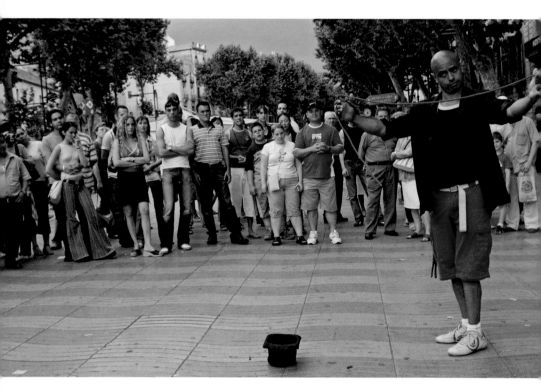

In this part of the Mediterranean the word Rambla means a riverbed of a stream where the rainwater from the mountain passes and flows into the seas. The Rambla of Barcelona has changed water for people and now takes the form of a dual channel: everything that goes down comes back up. And all the people who sit down to look at those going past are looked at by the passers-by. The Rambla is both stage and stalls, cast and audience. Nobody in the Rambla, not even the most immobile passer-by of all, is a passive character. If the world, due to a strange and undesirable cataclysm, was about to disappear, the survivors would meet up on the Rambla, where good luck and misfortune share a common ground of good understanding.

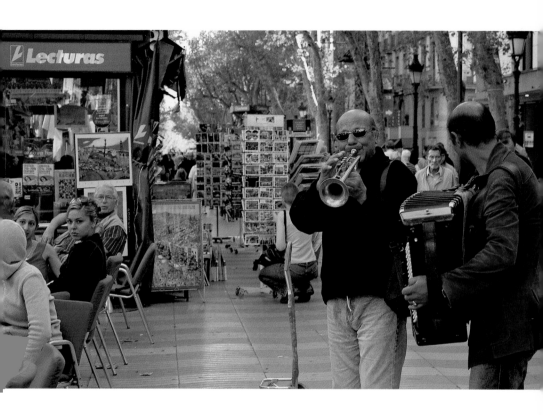

La Rambla. The Escribà cake shop →
La Rambla. Cafè de l'Òpera →→

DE LA
PETXINA

F^{ca} de PASTAS ALIMENTICIAS

Tapiocas

Bombons

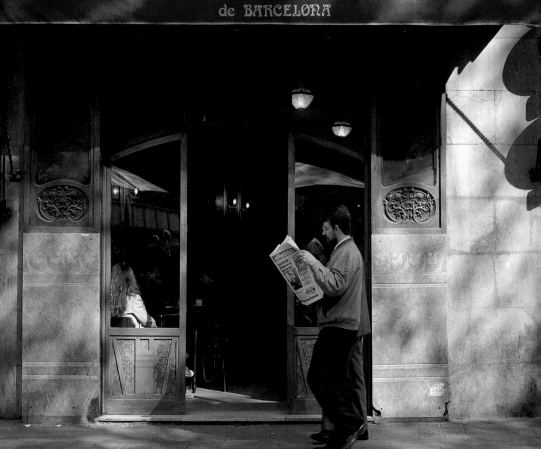

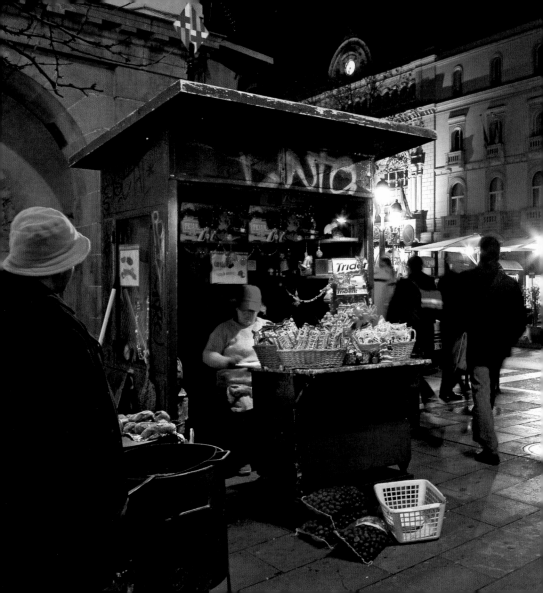

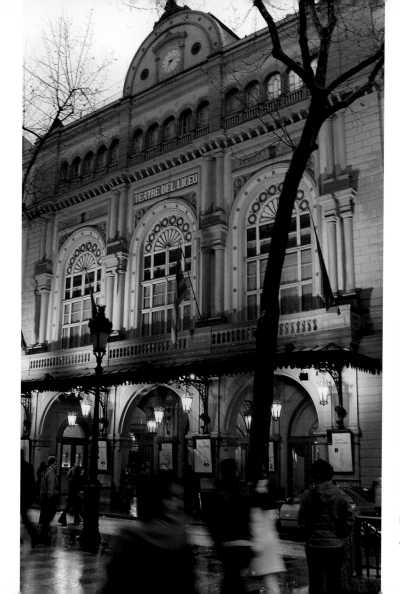

La Rambla. Chestnut and sweet potato stand

Gran Teatre del Liceu, 1844-1848. M. Garriga i Roca.
Reform and enlargement, 1990-1998. I. Solà-Morales, X. Fabré and Ll. Dilme

159

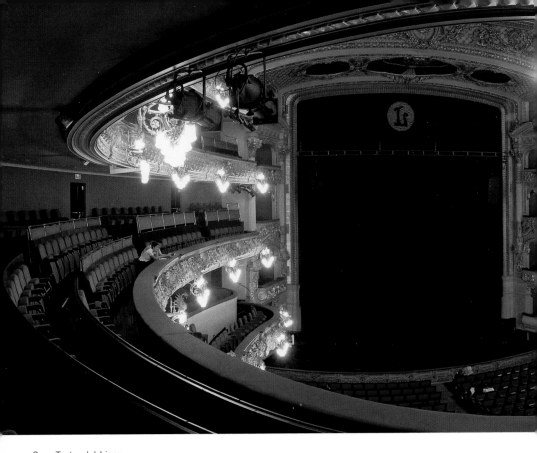

Gran Teatre del Liceu

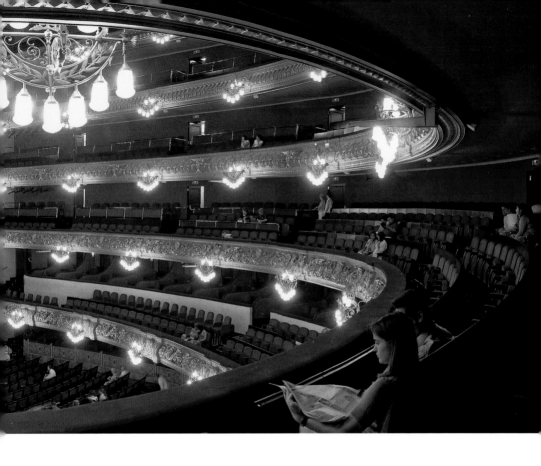

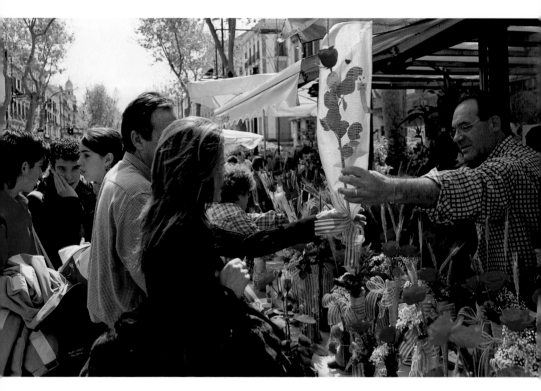

Until now no better tool has been found for preserving the memory, for letting the imagination run wild and for condensing the beauty of words than a book. On Saint George's Day the city is full of books, the mission of which is to remind the citizens that the printed word is life insurance for the soul. The day is complemented with the selling of roses. There are those who argue it is a festival of love, but for the Catalans it has become the festival of love for one's own self-esteem.

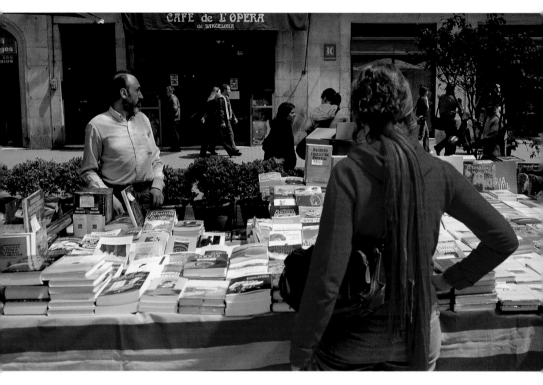

La Rambla, 23rd of April, Saint George's Day

La Rambla, 23rd of April, Saint George's Day →

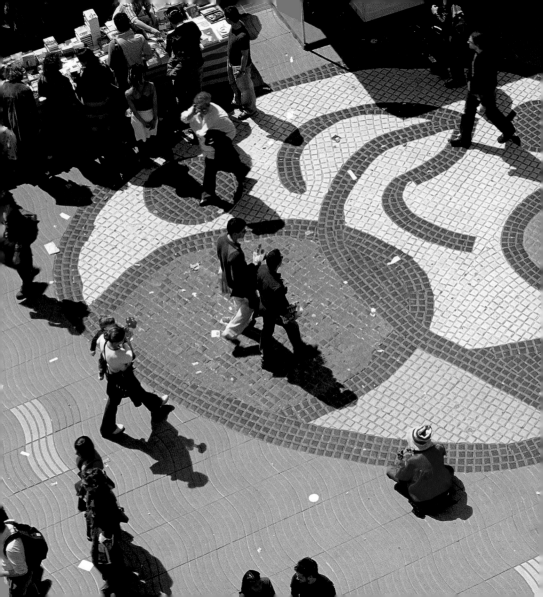

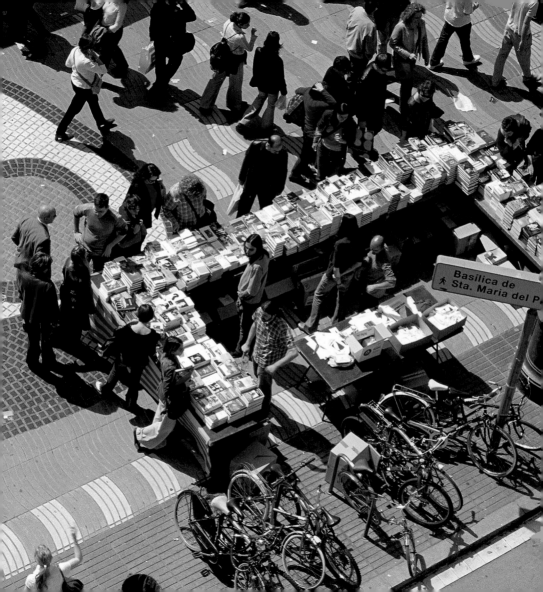

Basílica de
Sta. Maria del P

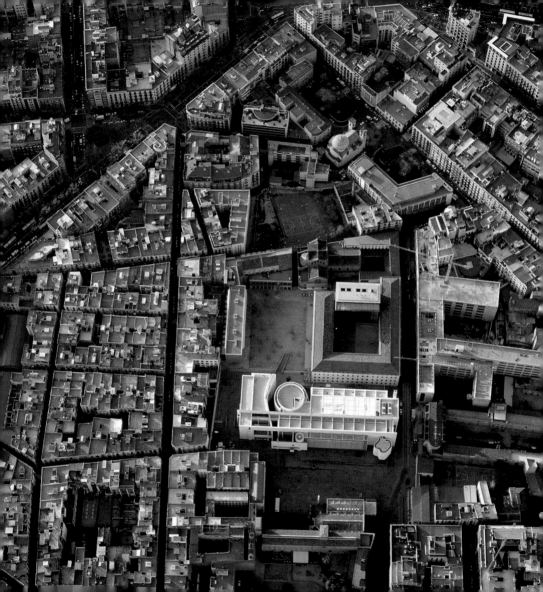

La Ola, 1998. Jorge Oteiza

The Raval district, Plaça dels Àngels, MACBA, CCCB

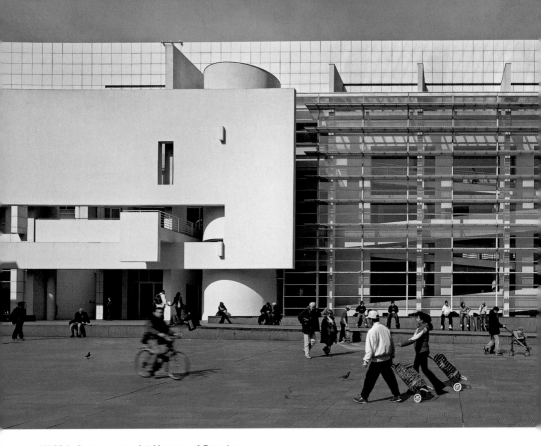

MACBA, Contemporary Art Museum of Barcelona
1988-1995. Richard Meier & Partners

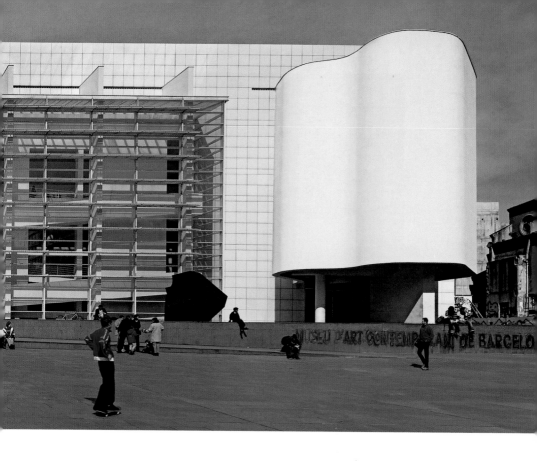

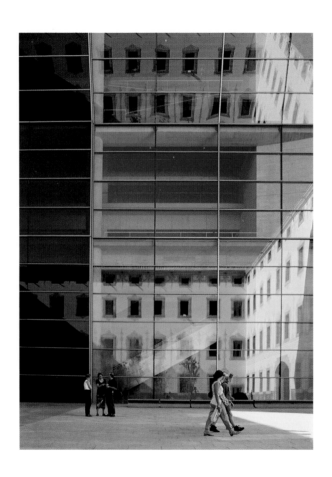

CCCB, Centre for Contemporary Culture of Barcelona,
1990-1994. Helio Piñón and Albert Viaplana

CCCB

172

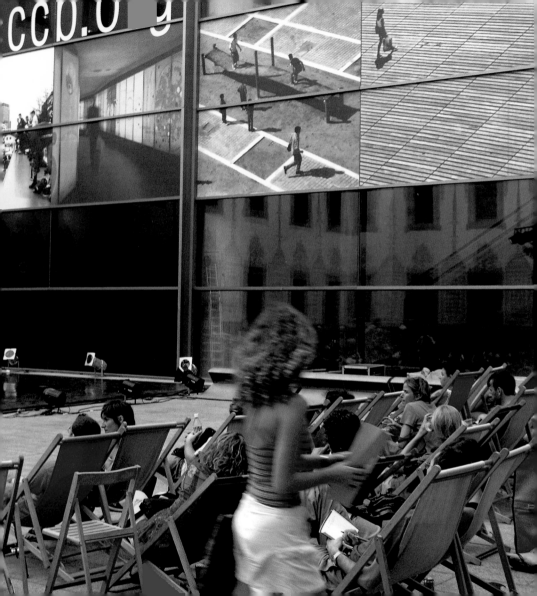

The narrow cities with the vocation of a Kasbah have seen how, amid the labyrinth of streets, new squares and spaces with splendid installations grew up amongst them. This urban work is given the name "sponging-up". In fact, the capacity for absorption and distillation of these spongy districts has been shown to be highly efficient. All that was required was to close off the art in a luminous box for the streets to be filled with different shades and arts and crafts. Today, the Raval district is the most multicoloured, varied and at the same time most homogeneous district in the city. Absolutely everything is where it should be and every street corner seems to us like a different part of the world.

The Raval district

The Raval district

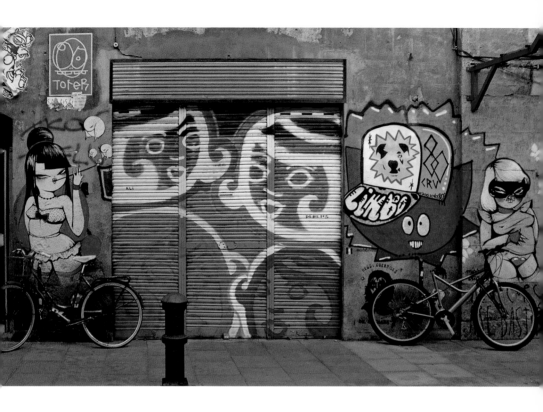

The Raval district →

MIDDLE
CLASSES

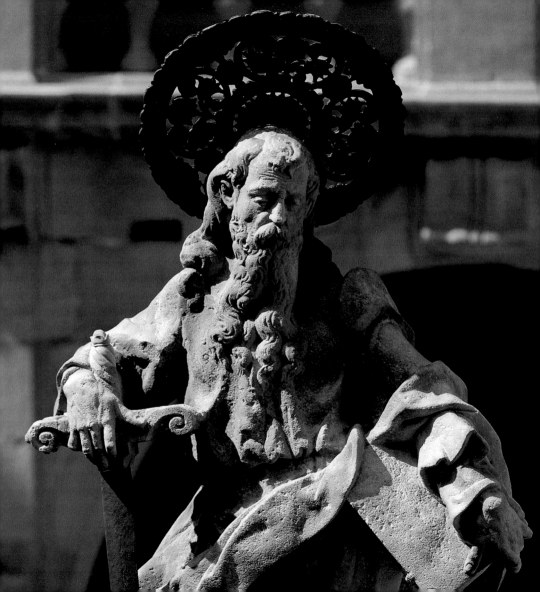

The Raval district. Seated on the wall. Street show by Angie Hiesl

Saint Paul, 1678. Lluís Bonifaci.
Casa de Convalescència, 17th century,
home of the Institut d'Estudis Catalans

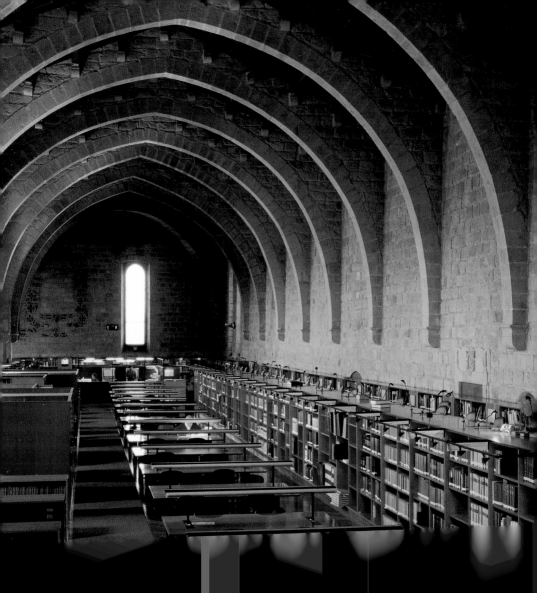

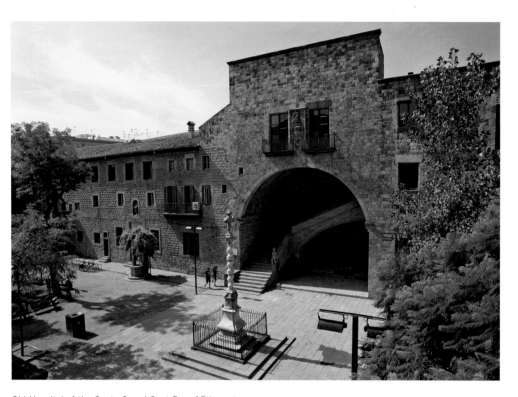

Old Hospital of the Santa Creu i Sant Pau, 15th century.
Home of the National Library of Catalonia

Casa de Convalescència, 17th century →
Hotel España, Carrer de Sant Pau, 9-11. Paintings by Ramon Casas, 1902 →→

Church of Sant Pau del Camp, 10th century

Carrer Nou de la Rambla

Palau Güell, 1886-1888. Antoni Gaudí

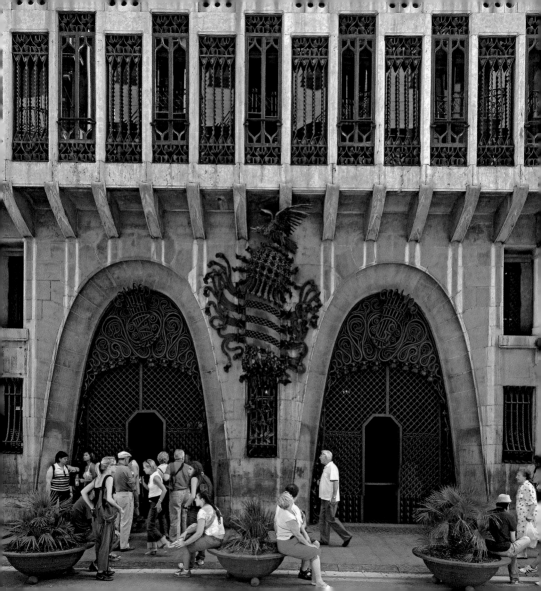

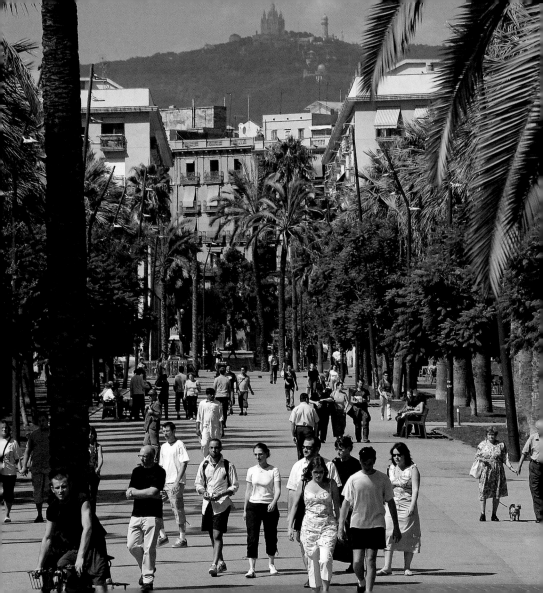

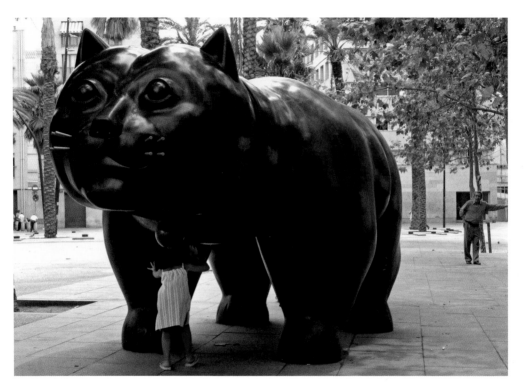

Gat, 1989. Fernando Botero

Rambla del Raval

The Boqueria Market, 1860 →

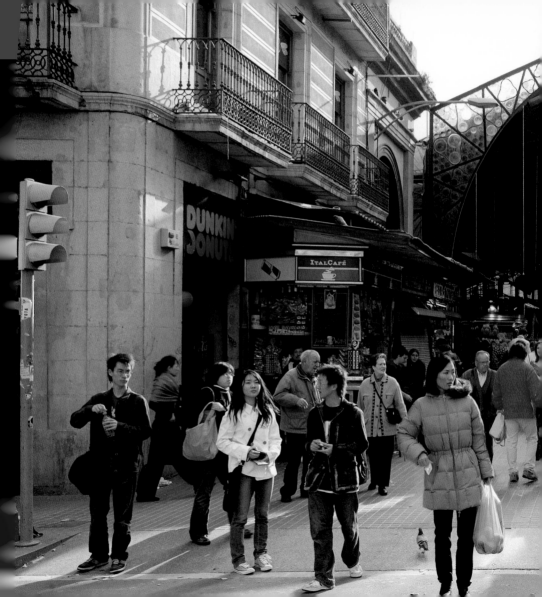

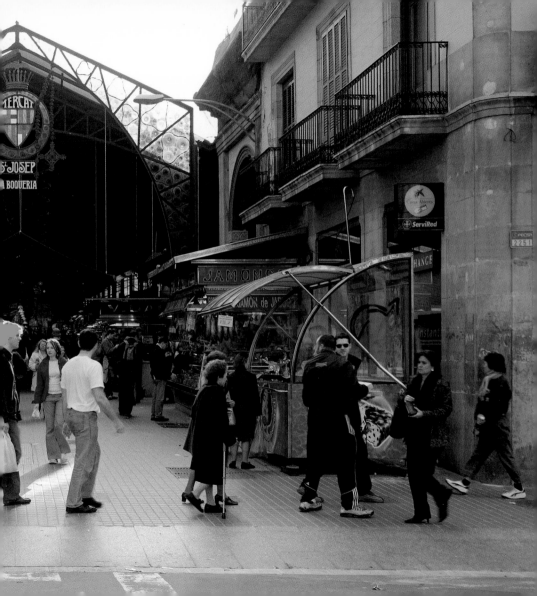

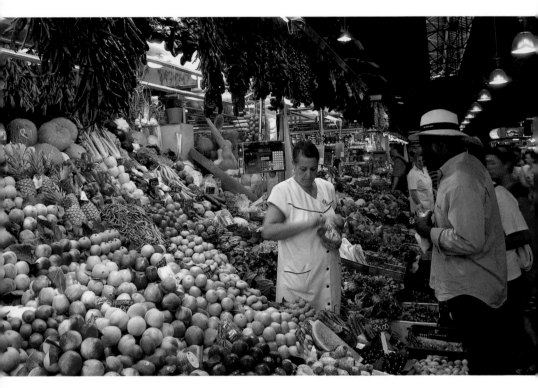

Humanity has built temples to pray to the gods to free them from scarcity. There are also new temples, however, that are devoted to abundance. The market of the Boqueria is one of them. In reality, more than a large market it is a small museum of dead natural phenomena. Among all the people who pass through it, some go there to shop, but many go to recall the orange colour of the orange and the meaty colour of meat, the aroma of seafood and the earthy aroma of the produce of the land. The Boqueria is the heart of the earth of all worlds, the covered square where the Latin saying *primum vivere, deinde philosophare* comes true. First of all we live. The city will have time to dedicate itself to thought and doubt later.

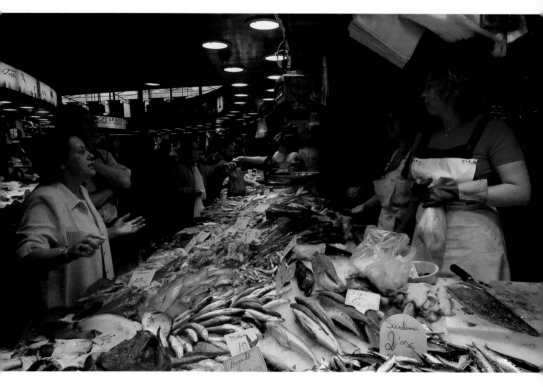

The Boqueria Market

Ciutat Vella. Gastronomic diversity →

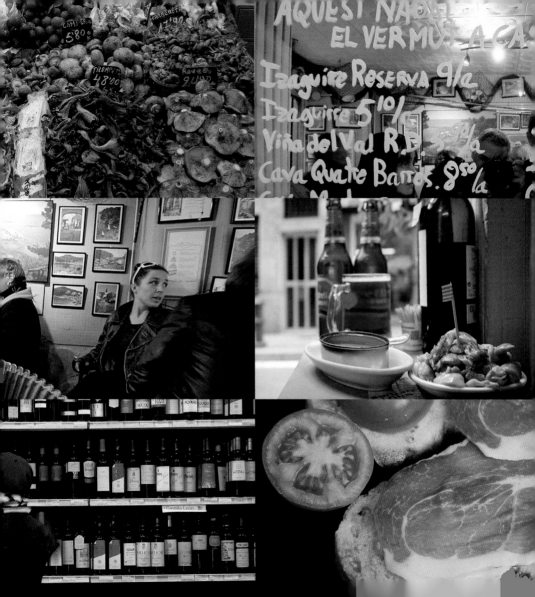

The *ferrissa* is an iron bar that was once used as a unit of measure in Barcelona. The *ferrissa*, which measured everything that entered and left the city, was located in one of the old entrance gateways: the Porta Ferrissa.

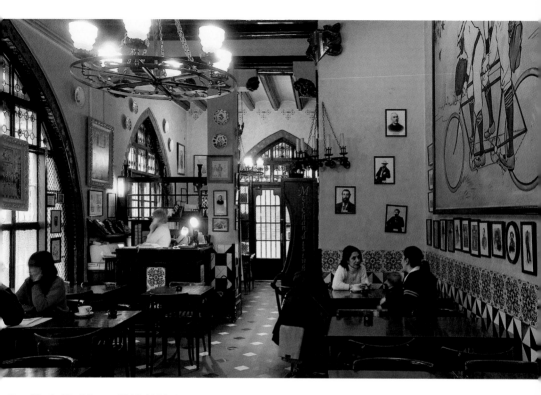

Casa Martí «Els 4 Gats», 1895-1896. Josep Puig i Cadafalch

La Rambla. Masó Chemists

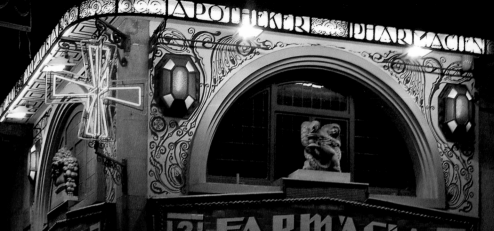

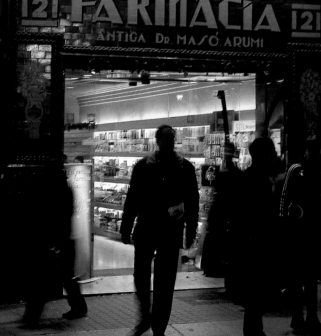

APOTHEKER · PHARMACIEN

FARMACIA
ANTIGA Dr. MASÓ ARUMÍ

FARMACIA

121 121

Plaça Catalunya

Ateneu Barcelonès

La Rambla. Fountain of Canaletes

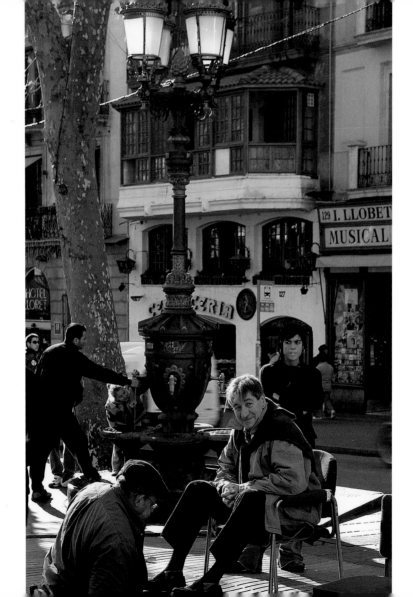

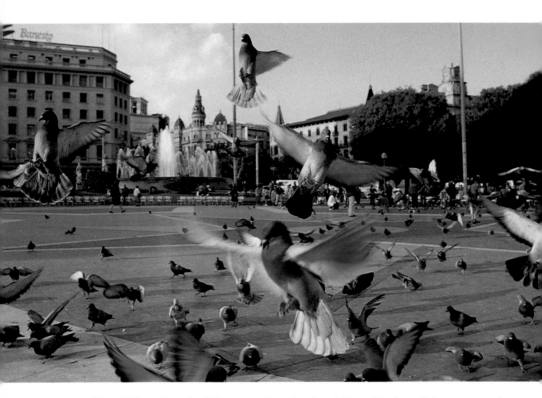

At the apex of Ciutat Vella and from the 19th-century city someone left a hole without buildings for the starlings to shelter in, the children to play in and the pigeons to fill. In the past European squares were the homage paid to the space owed to the Gothic cathedrals. Today the Plaça de Catalunya is a space at the service of banks and department stores. It is above all, however, a meeting place for all those who wish to be citizens of Barcelona. In the centre of Plaça de Catalunya, on this enormous compass, it is always peaceful. It is the spot where all paths are open. Centripetal or centrifugal, from this point everything leaves and everything arrives.

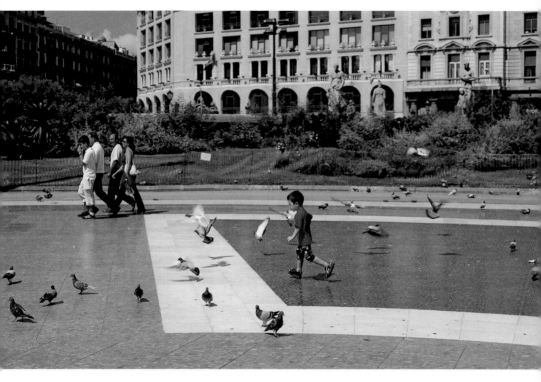

Plaça de Catalunya, 1925-1927

Plaça de Catalunya →

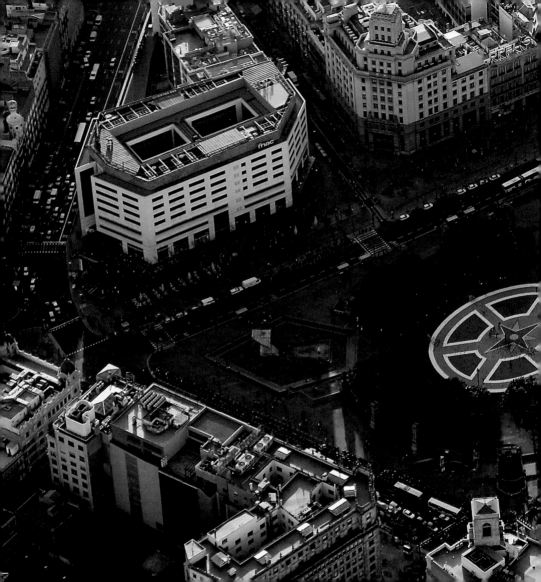

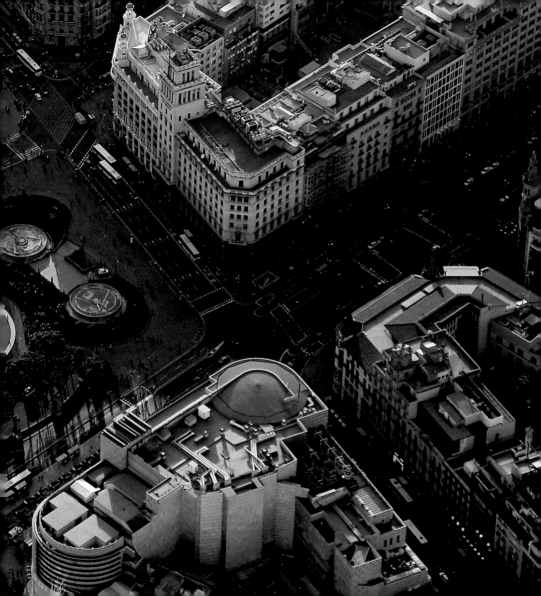

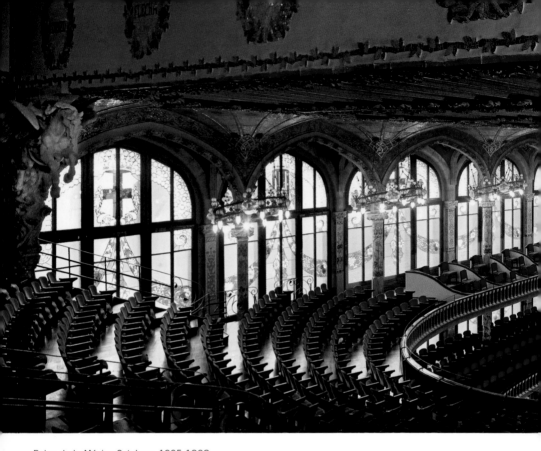

Palau de la Música Catalana, 1905-1908.
Lluís Domènech i Montaner

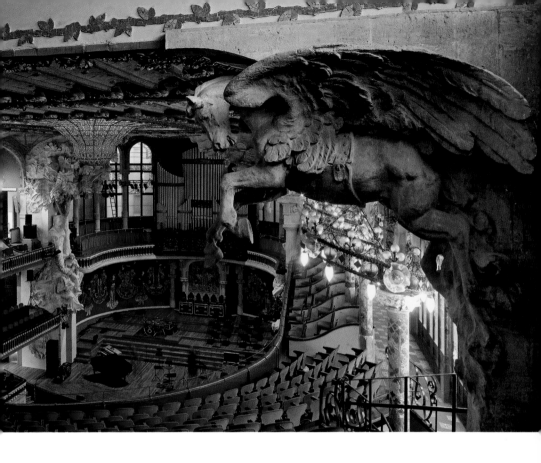

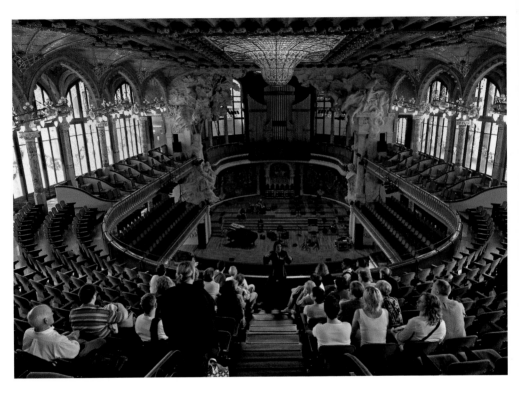

The capitals of nations without a State have these things. Public money has not built the palaces. Nor have grand patrons. Art has arisen from the people and that was how one hundred families dedicated to choral singing and the cultivation of music contributed to erecting this fundamental piece of modernist architecture on their small site. No grand avenues or grand squares. The beauty was inside. And the excess of stone resulted in one of the halls with the best acoustics in the world.

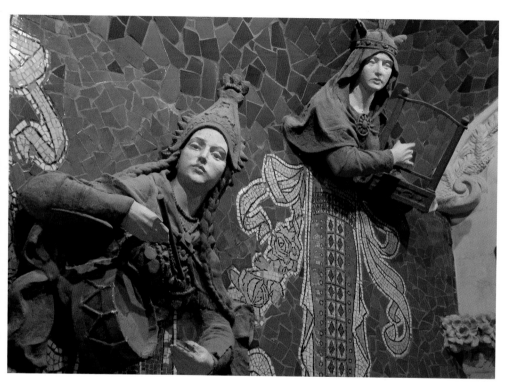

Palau de la Música Catalana

A century after the architect Domènech i Montaner, the architect Tusquets came to dignify that which was already worthy. Today the harmony is no longer restricted to inside the walls. The people who pass near to the Palau de la Música stop talking lest the noise of the city awakens the muses.

Sgraffito from different periods →
L'Eixample →→

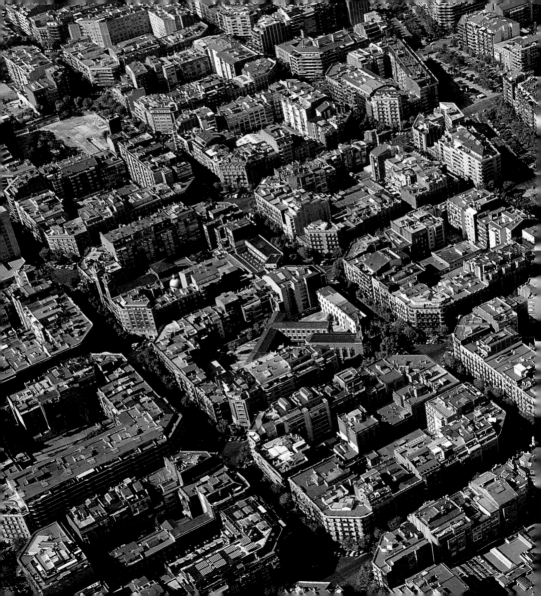

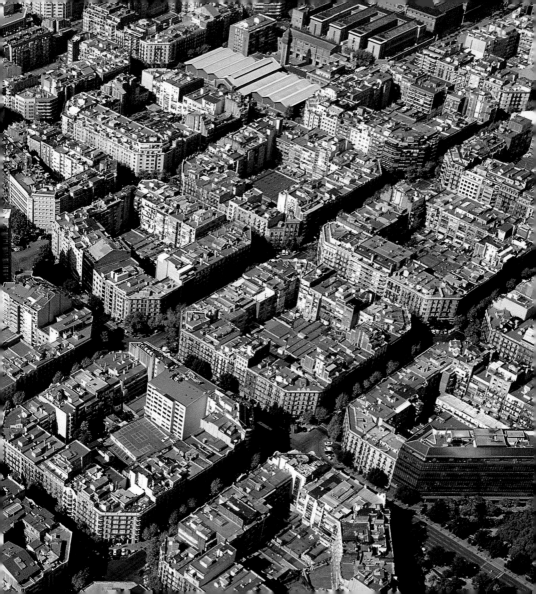

Casa Lleó Morera Casa Amatller

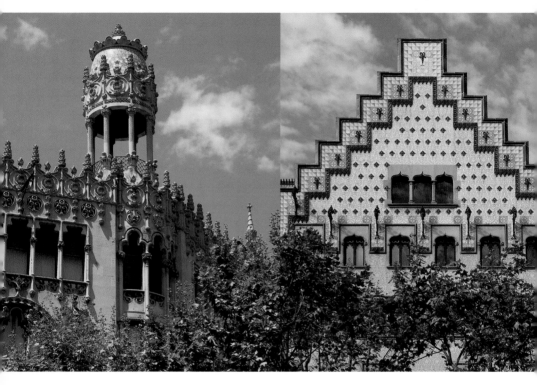

And suddenly the small city broke the straightjacket of the walls and went crazy. 'What a lot of property for development!' must have been the cry of the old conquerors of the great plain of Barcelona. And there, where over the centuries there had been orchards and country houses, there where the siege armies had been billeted, they began to design rectilinear streets. First the streets, then the houses. And a magnificent grid of squares covered the plain. And even in the square blocks Cerdà cut the corners off so that the crossroads were squares. And, then when everything was ready and planned, the madmen came and began to turn the stone into an elastic and mouldable material and, under the label "modernism" the windows were no longer

La Pedrera Casa Batlló

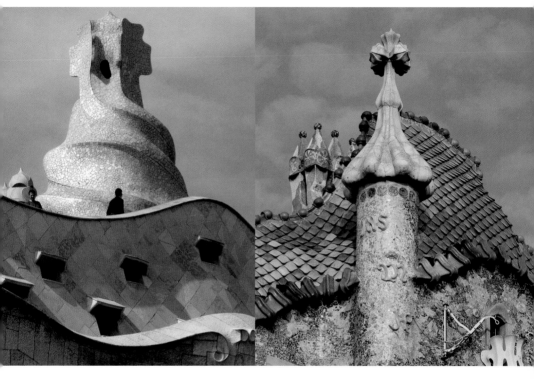

rectangular and the roof tiles no longer the same colour. The bonfire of the vanities had been lit and the wealthy fortunes of the period wished to distinguish themselves from the neighbouring fortune. The house in Barcelona would never be a castle but its ambition was to show the people of Barcelona who was capable of competing in audacity, originality, architecture and in the wages of so many craftsmen who gave shape to the geniality of the architects. Even humble folk such as those of the Orfeó Català caught the bug of the new style and erected the Palau de la Música in the narrow street where they owned the site. Stone had finally been given the power to speak. And even today its dreams reach us in a strange harmony.

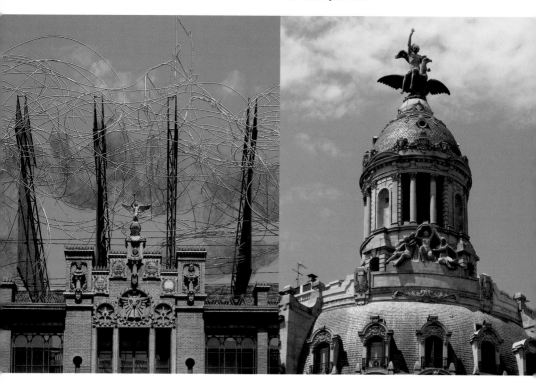

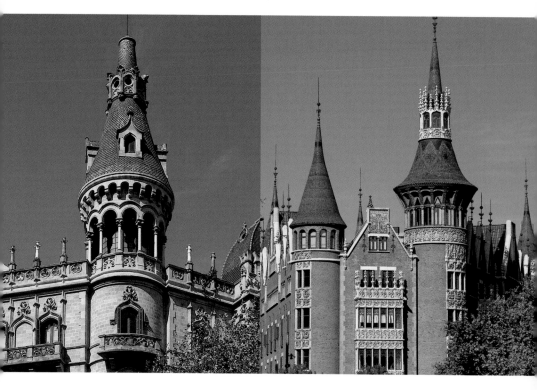

Passeig de Gràcia. «The *Manzana,* apple or block in Spanish, of discord» →
Casa Lleó Morera, 1905. Lluís Domènech i Montaner →→

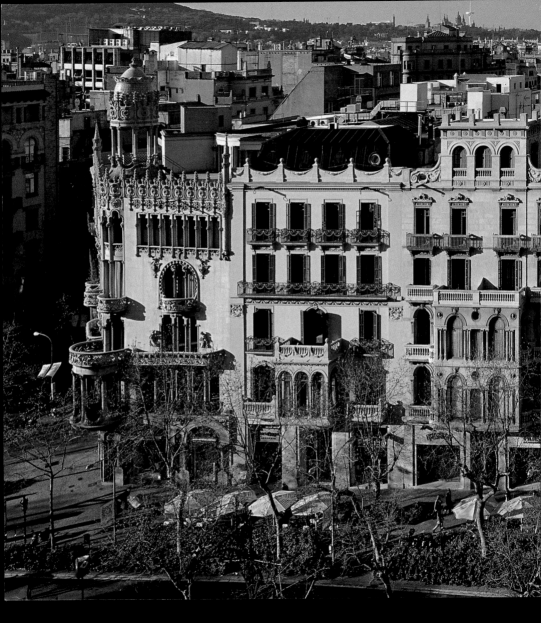

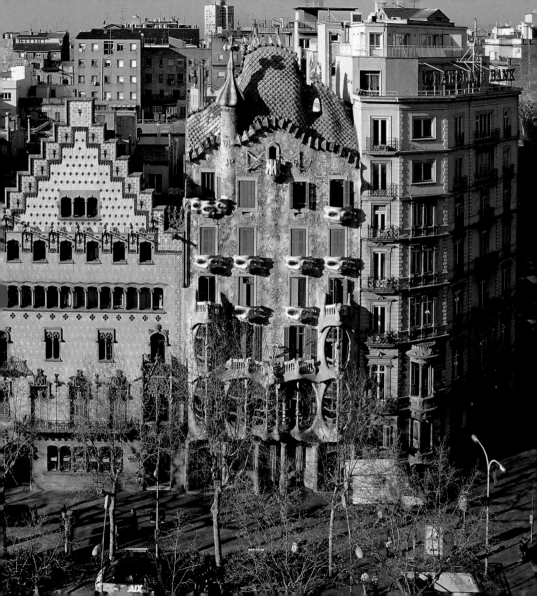

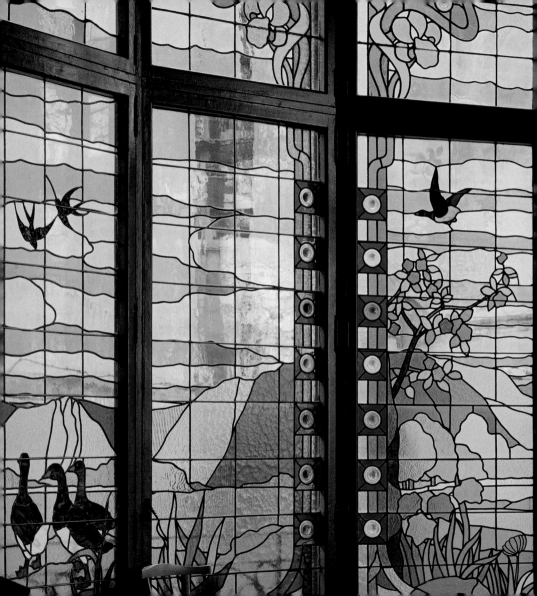

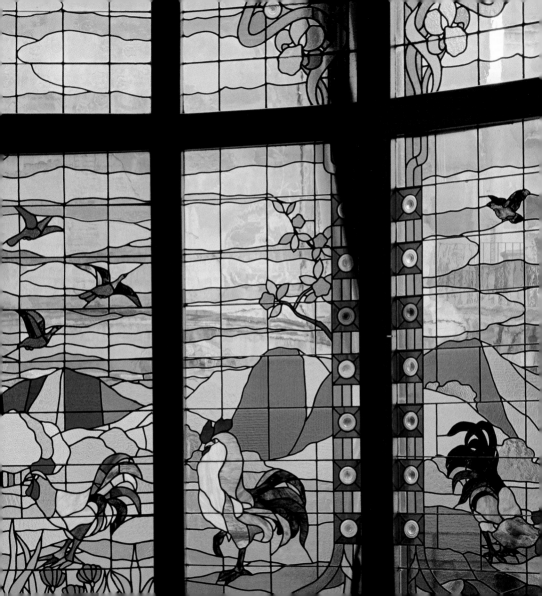

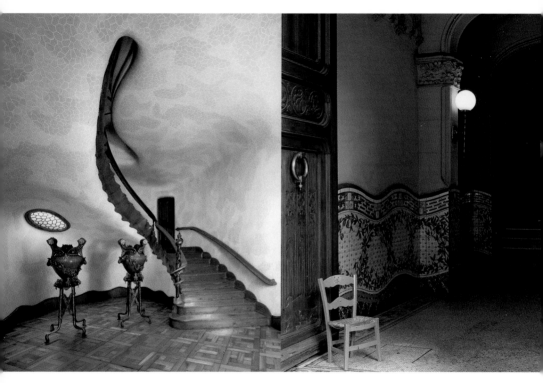

It must have been at night when the right angles disappeared, because they were not found again for a long time after. The next day the plain of Barcelona saw flowers grow and birds fly and noted that the houses no longer had windows but eyes. Modernism is the translation into stone of the vanity of money. The wealthy of Barcelona wanted to show their competitors that they were getting increasingly richer and bolder and found the

possibility to express this desire in architecture. On these façades there is, naturally, the genius of the architect and the skill of the craftsmen who worked on the construction. Also present, however, is the willingness for distinction. Architects driven crazy by form and a bourgeoisie who wanted to show off were destined to meet each other. This was how the madness of stone came to be worth more than any stiff titled distinction.

Casa Iglesias

Casa Comalat

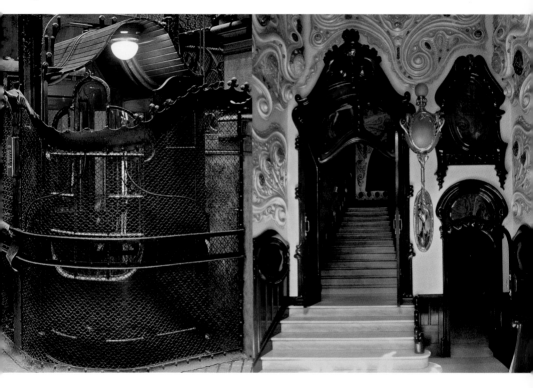

Casa Manuel Llopis, 1902-1903. Antoni M. Gallissà →

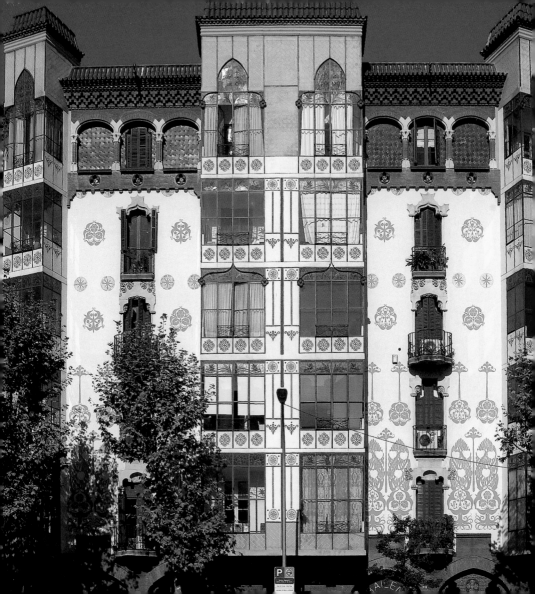

Casa Jeroni F. Granell, 1904. Jeroni F. Granell

Montaner i Simó Publishing House, 1881-1886. Lluís Domènech i Montaner.
Home of the Fundació Tàpies

Modernist details →

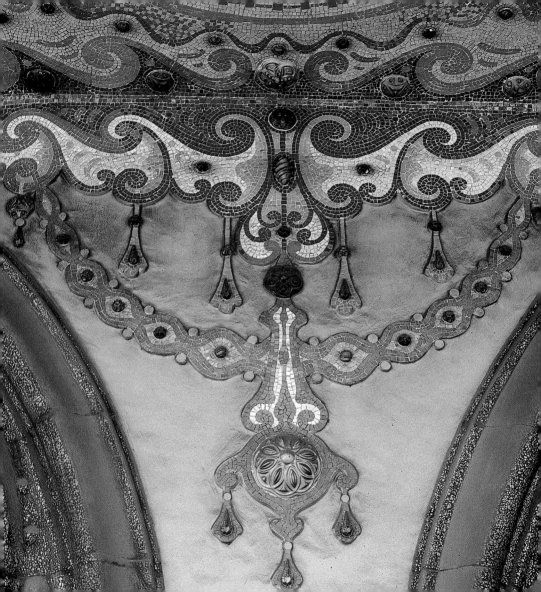

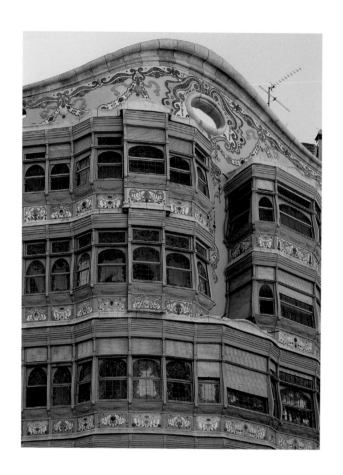

Casa Comalat, 1909-1911. Salvador Valeri i Pupurull

Casa Sayrach, 1915-1918. Manuel Sayrach →

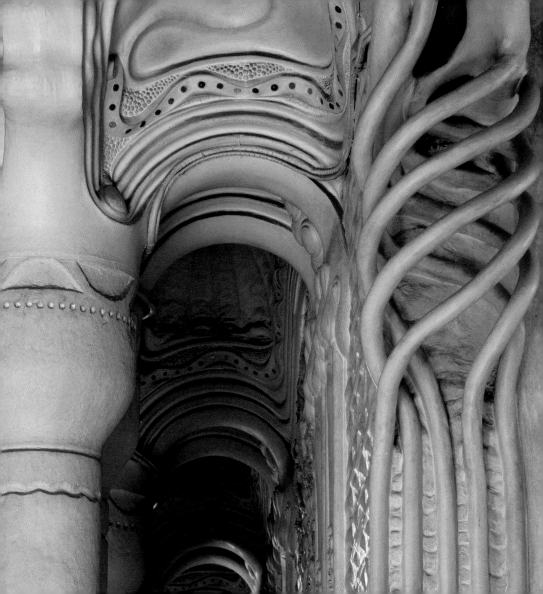

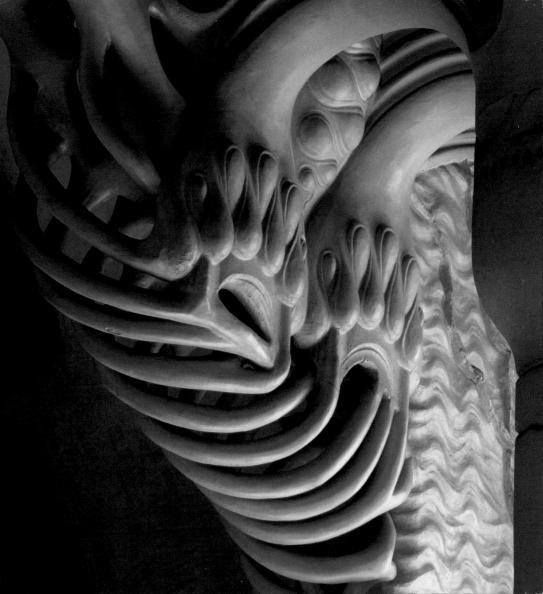

Casa Macaya, 1899-1901. Josep Puig i Cadafalch

Palau Quadras, 1899-1906.
Josep Puig i Cadafalch

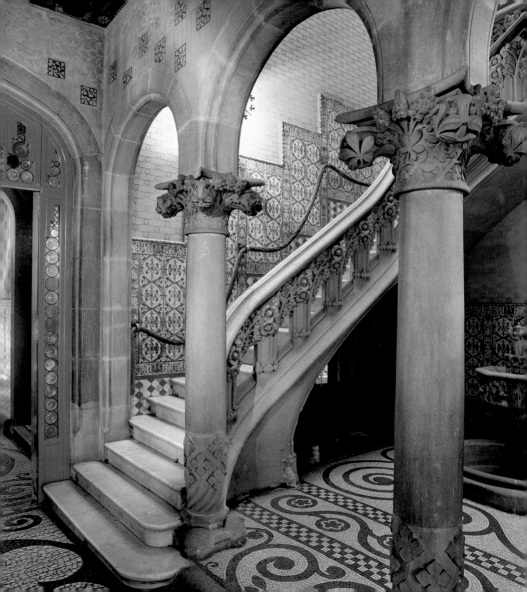

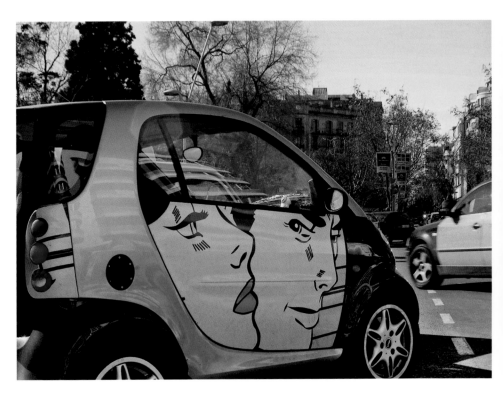

The typical black and yellow taxi and the tourist bus of Barcelona form part of an urban mobility policy that aims to make the streets more amenable and comfortable for the local people and visitors to Barcelona.

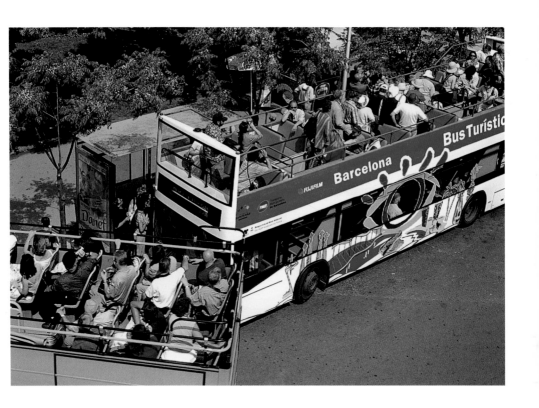

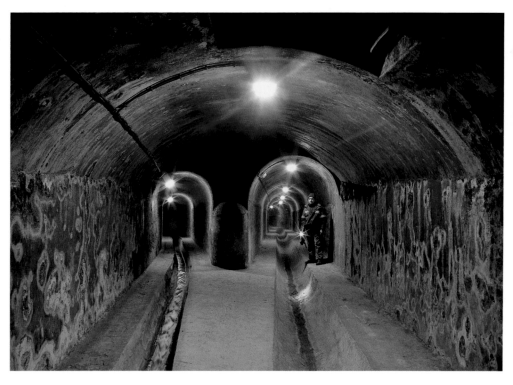

Barcelona's underground drainage system is 1,663 kilometres long. 35% of the system can be visited.

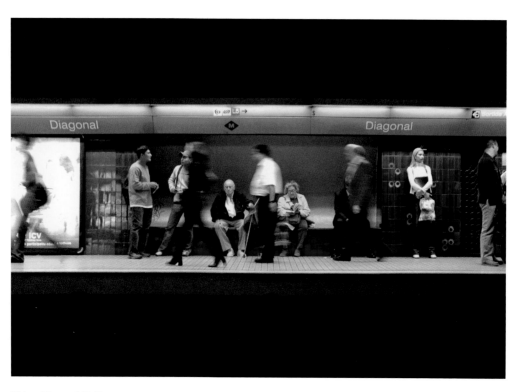

Metro. Diagonal Station

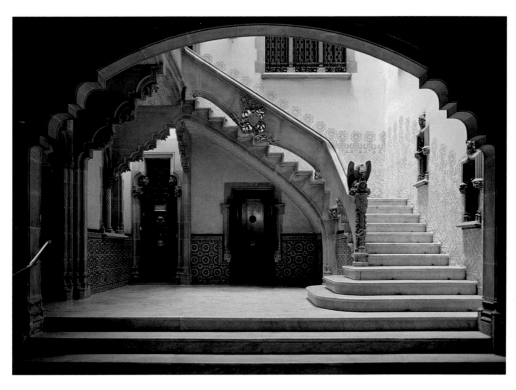

Casa Amatller, 1900. Josep Puig i Cadafalch

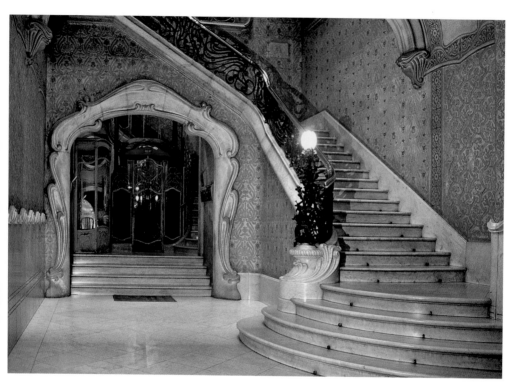

Casa Manuel Felip, 1901. Telm Fernández i Janot

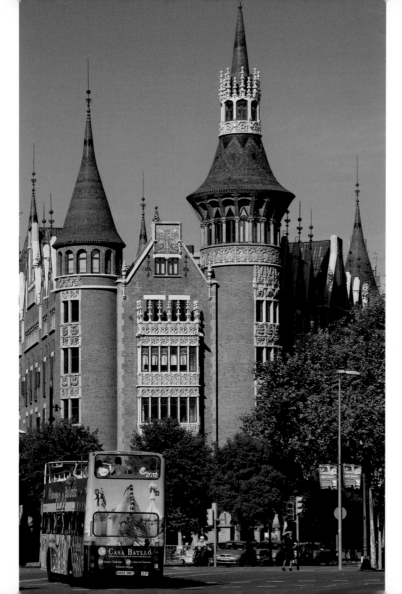

Lamppost-bench in Passeig de Gràcia, 1906. Pere Fàlqués

Casa Terrades «Casa de les Punxes», 1903-1905. Josep Puig i Cadafalch

255

Coqueta, 1972. Josep Granyer

Casa dels Cargols,
Carrer d'Entença, 2

You can see cities through both a telescope and a microscope. A city is a satellite image but it is also the drawer where grandma has guarded all her memories. In cities we all exist in objects. That is why we find it so hard to chuck them out and rid ourselves of them. And when we have no choice but to dispense with the objects we pass them on to someone else so that they can use them. At weekends in the Sant Antoni market are the items the city needs so that each citizen will not lose their individual memories. Buying and selling here represents the valuation of the spirit that exists in each object on display. It seems as if the objects change hands but in reality they continue to be in the same hands of the society that allowed them to be created.

Sant Antoni Market

Hospital of Santa Creu i Sant Pau, 1902-1911.
Lluís Domènech i Montaner→

259

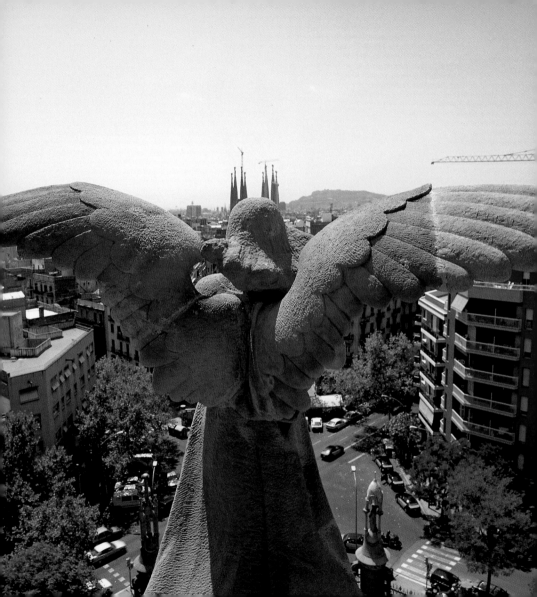

Hospital of Santa Creu i Sant Pau

L'Eixample

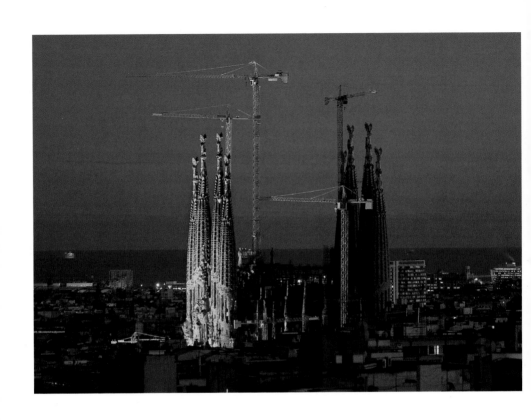

Temple of the Sagrada Família, 1883-1926 Antoni Gaudí

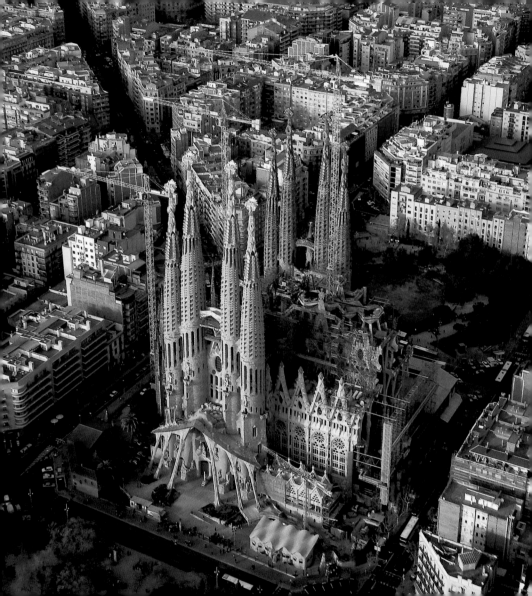

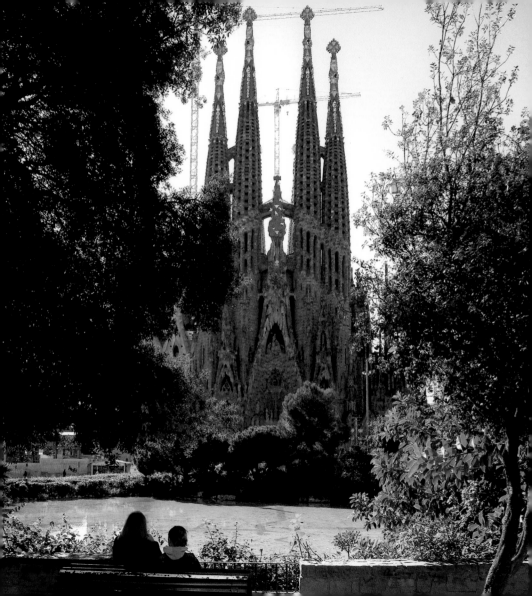

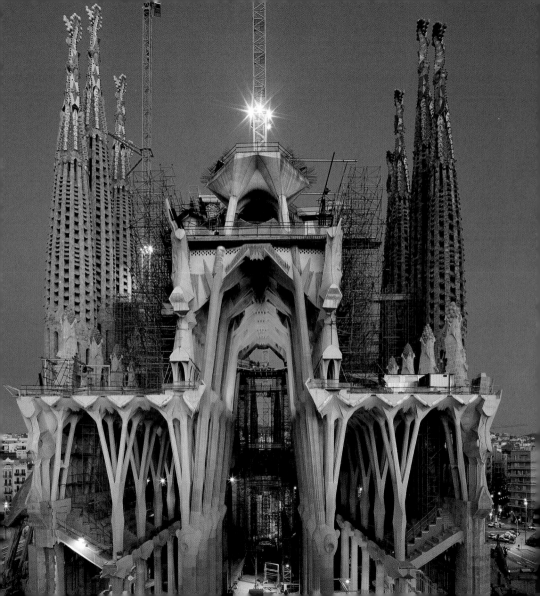

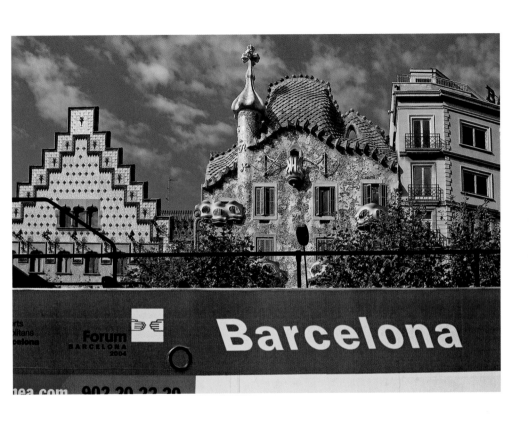

Casa Batlló, 1904-1907. Antoni Gaudí→

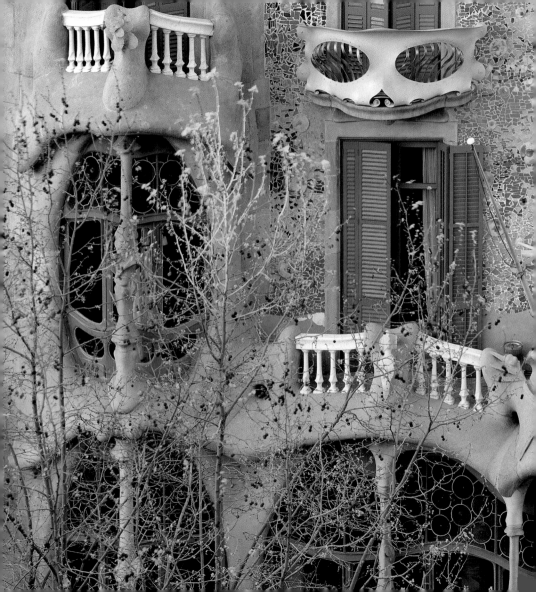

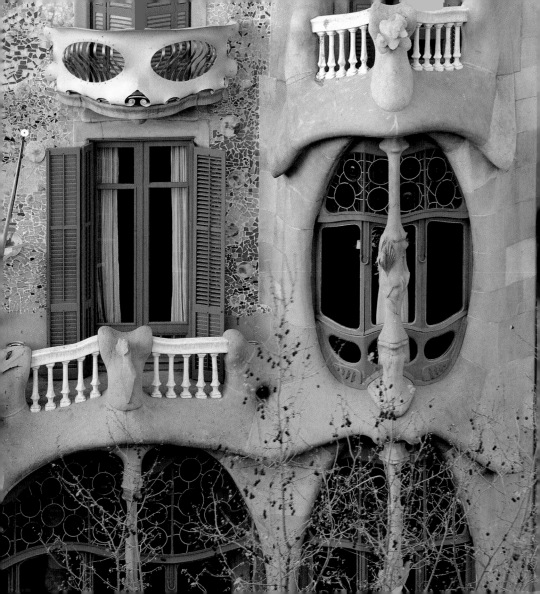

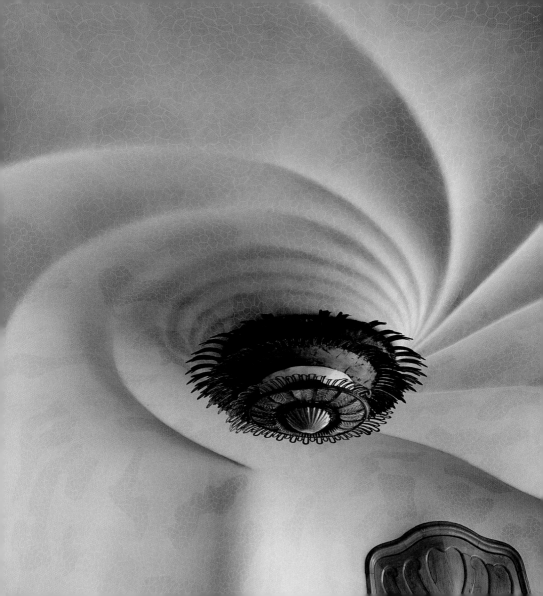

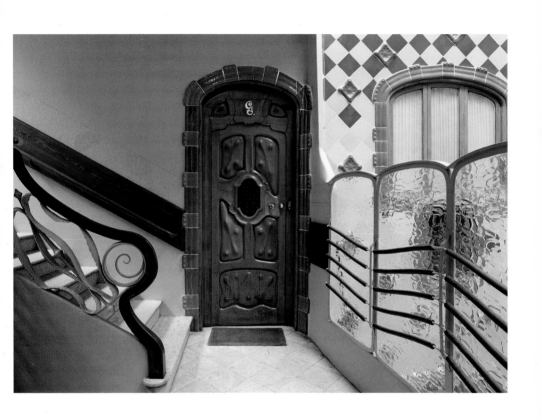

Casa Batlló

Casa Milà, «La Pedrera», 1906-1912. Antoni Gaudí→

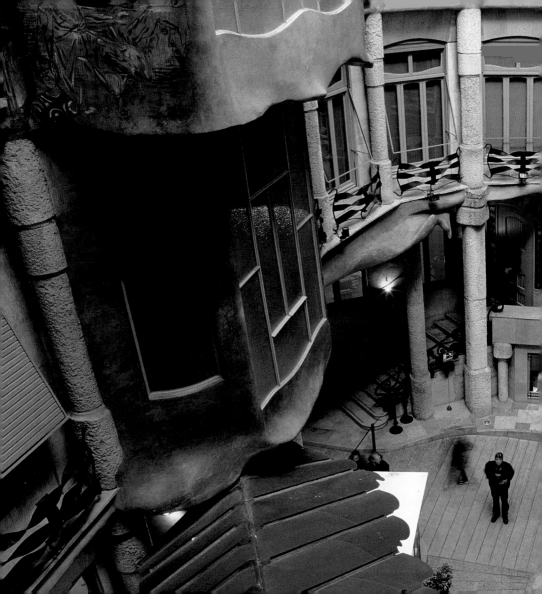

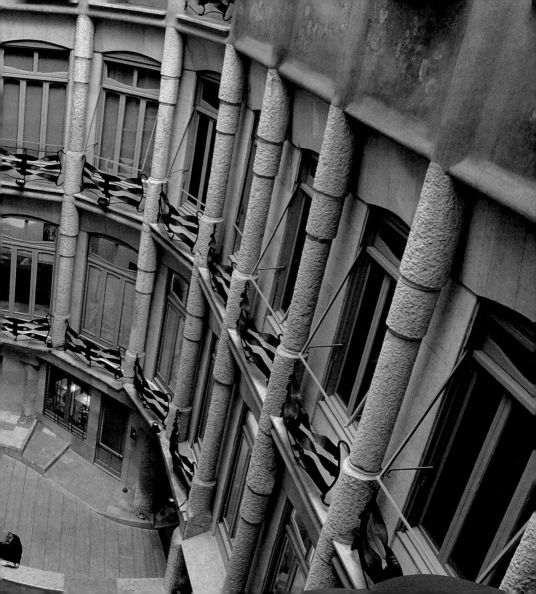

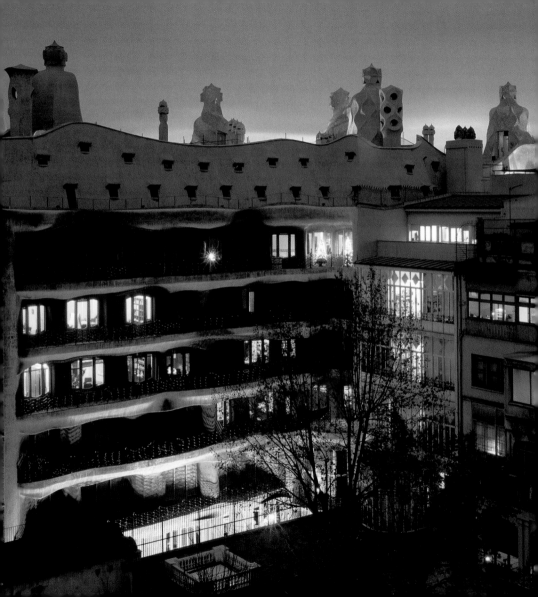

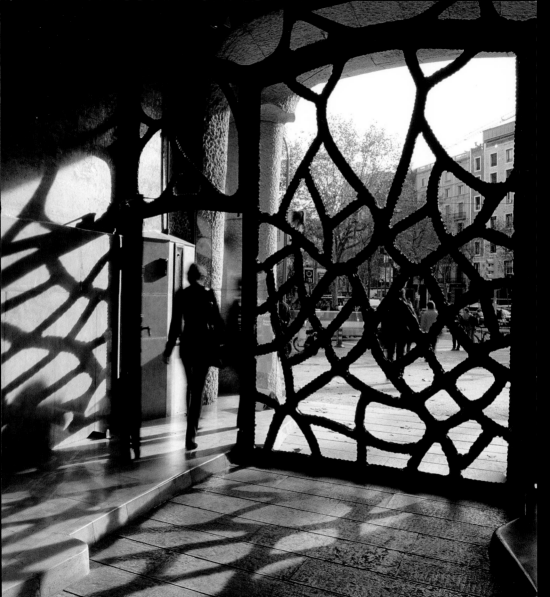

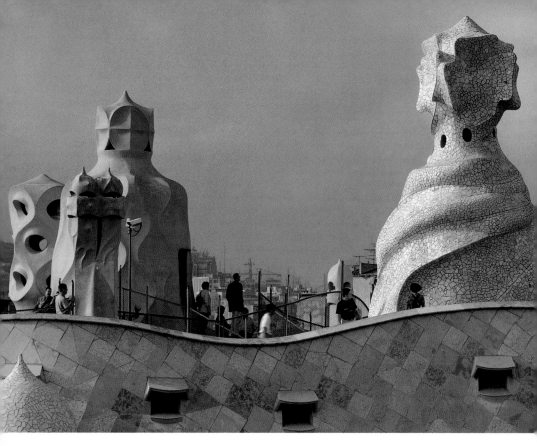

To the artistic and architectural merits of Gaudí should be added that of his ability to seduce his clients to persuade them to give him a totally free hand. Every corner, pinnacle, railing or window, ceiling or entrance door were turned into unique pieces by Gaudí which projected both the perfect forms of nature and the wild forms of the imagination. That which today dignifies the city was ridiculed by the press of the time. As the years have gone by, we have come to realise that Gaudí's universe is not restricted to the grand buildings but that it penetrates the smallest details of daily life. From a chair to the grand domes, from the doorknob to the public bench, Gaudí showed that in great art there are no minor genres.

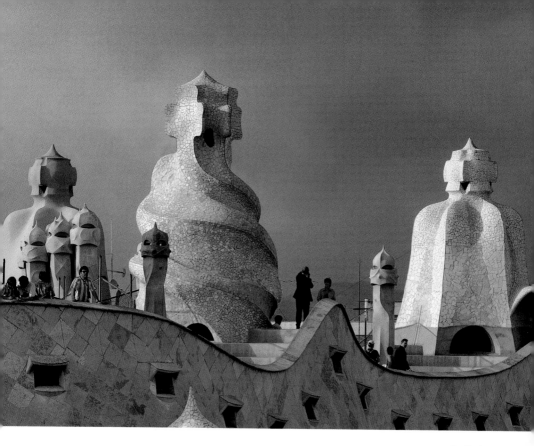

La Pedrera

La Pedrera →
Tower of Bellesguard, 1900-1909. Antoni Gaudí →→
Theresan College, 1888-1890. Antoni Gaudí →→→

279

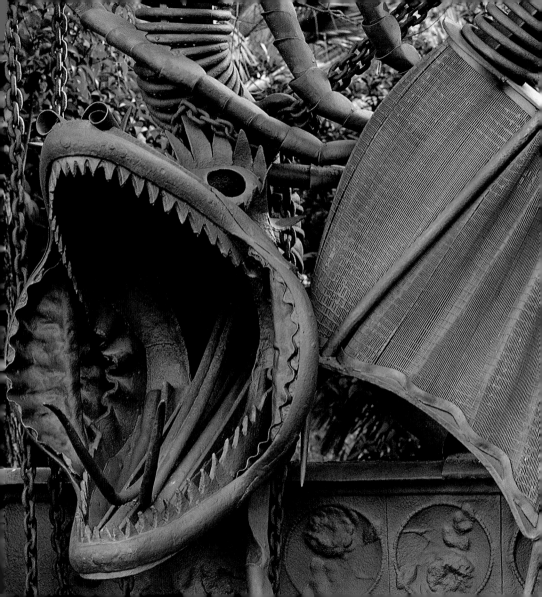

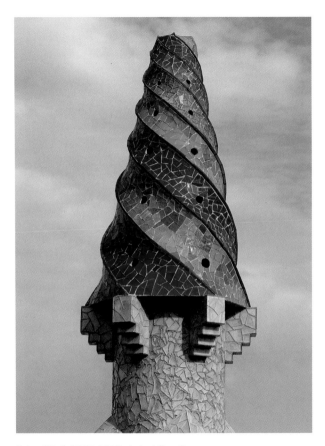

Palau Güell, 1886-1888. Antoni Gaudí

Pavilions of the Güell estate, 1884-1887.
Antoni Gaudí

Gaudian forms →

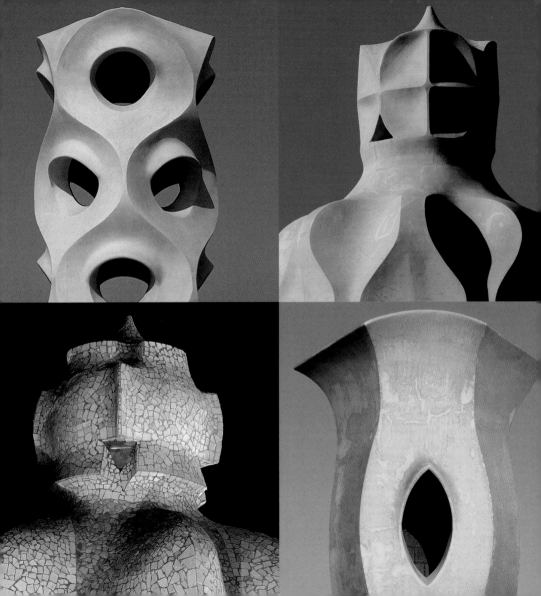

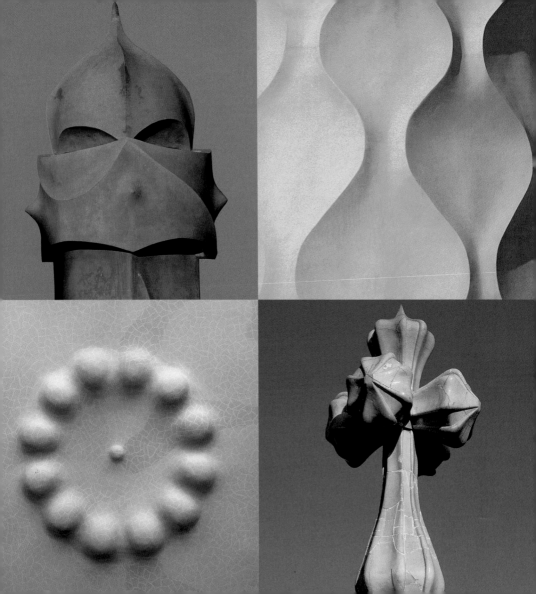

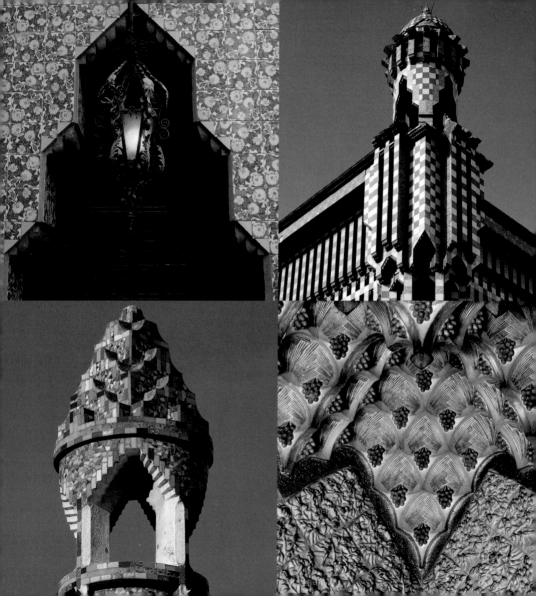

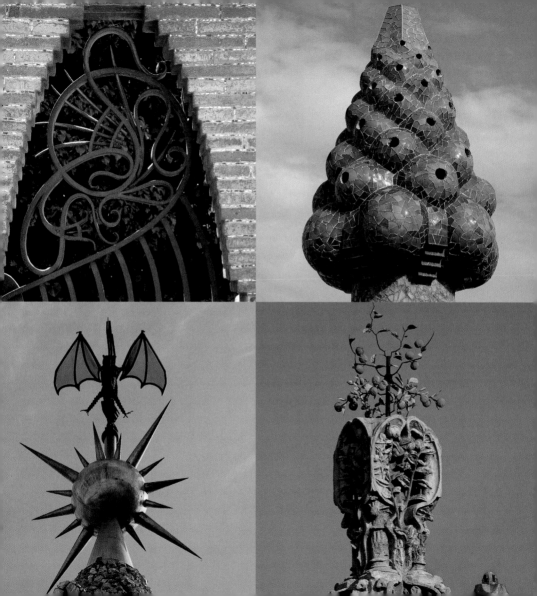

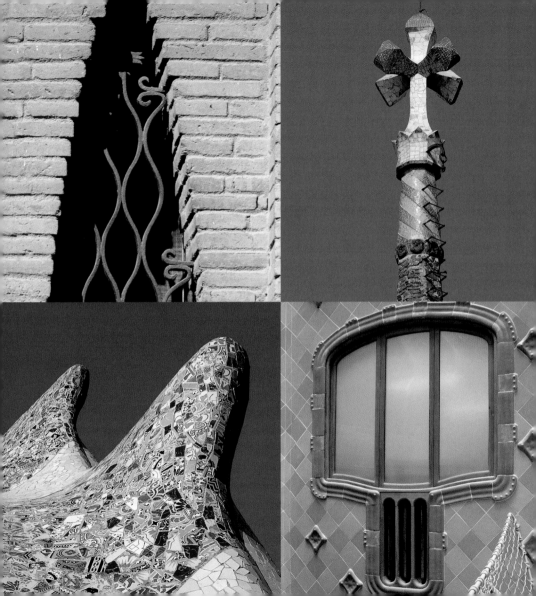

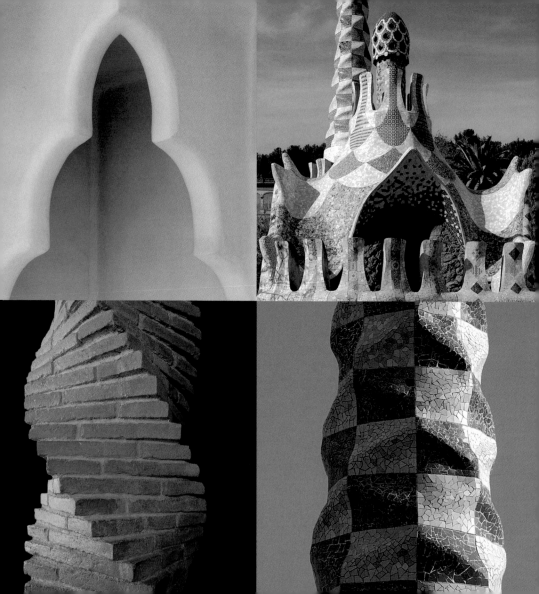

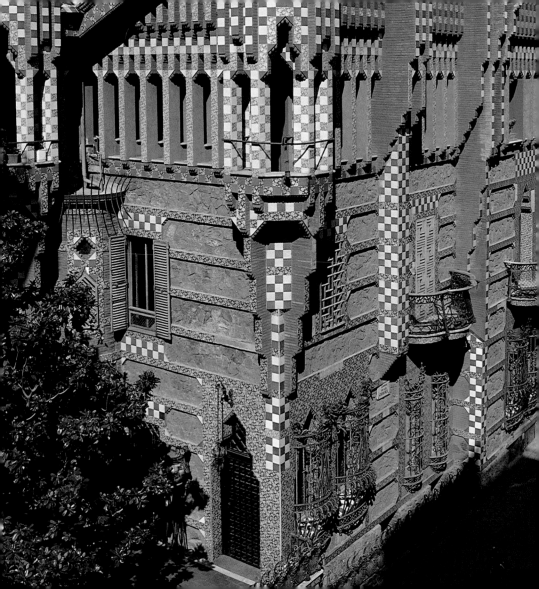

Casa Batlló

Casa Vicens, 1883-1888. Antoni Gaudí

Chair and peephole of the Casa Calvet,
1898-1900. Antoni Gaudí →

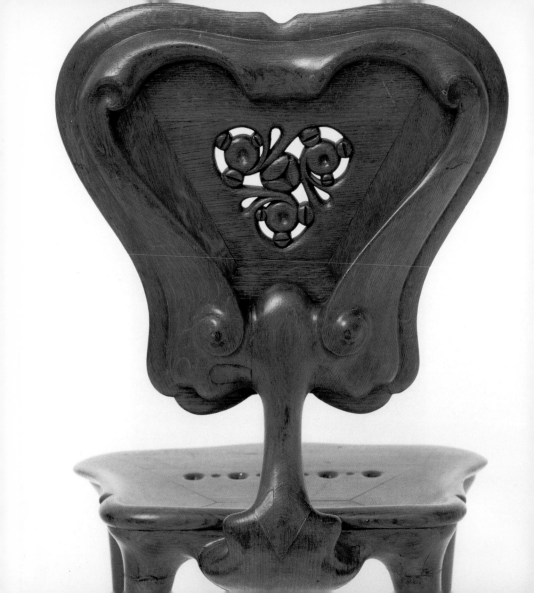

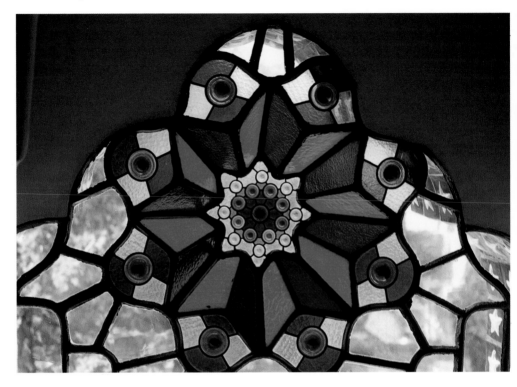

It is a difficult task describing the colour of cities. Sometimes, nonetheless, the colour comes from the sum of many colours. From broken tiles comes the polychrome that sparkles beneath the grey of the rain. The Mediterranean light filters through Gaudí's windows, draws shadows and invents movements until the eyes of the passer-by are turned into kaleidoscopes. Extolling the colours of Gaudí, the stones are made of cotton and the windows seem like butterfly wings.

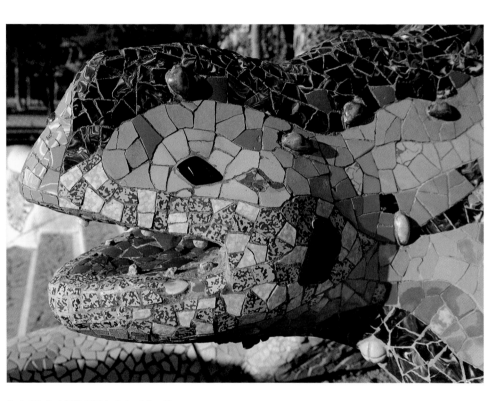

Park Güell, 1900-1914. Antoni Gaudí

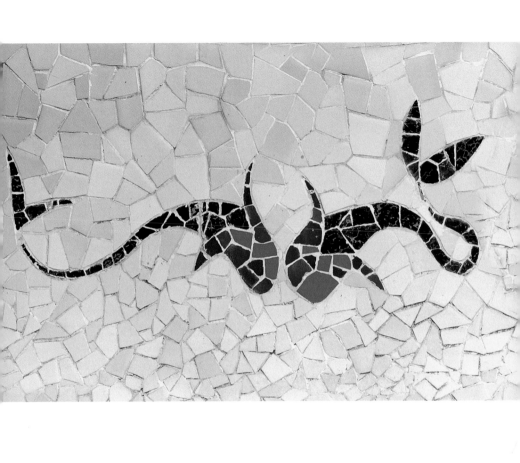

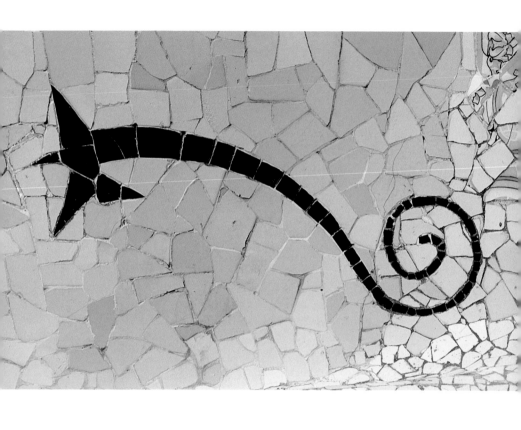

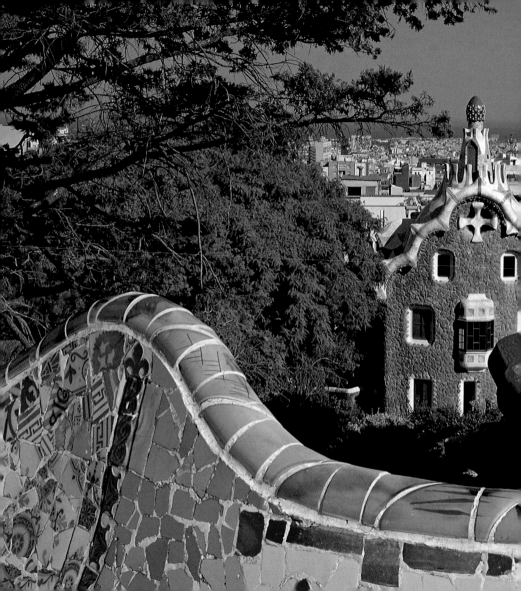

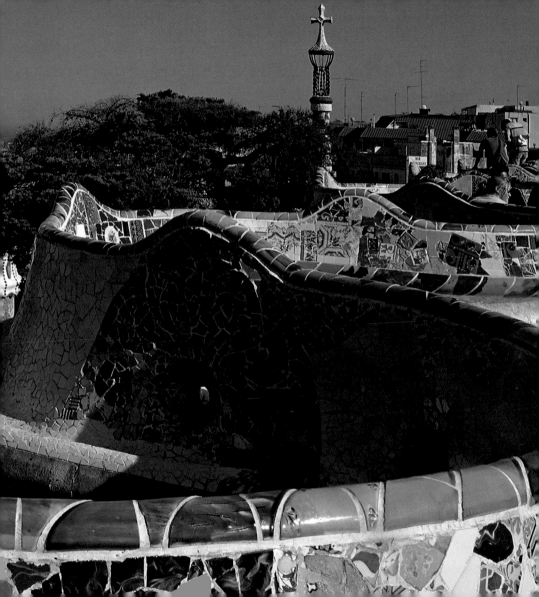

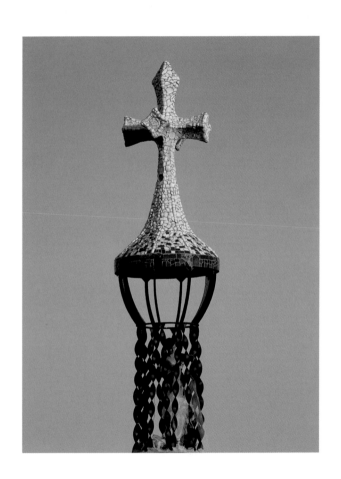

Park Güell

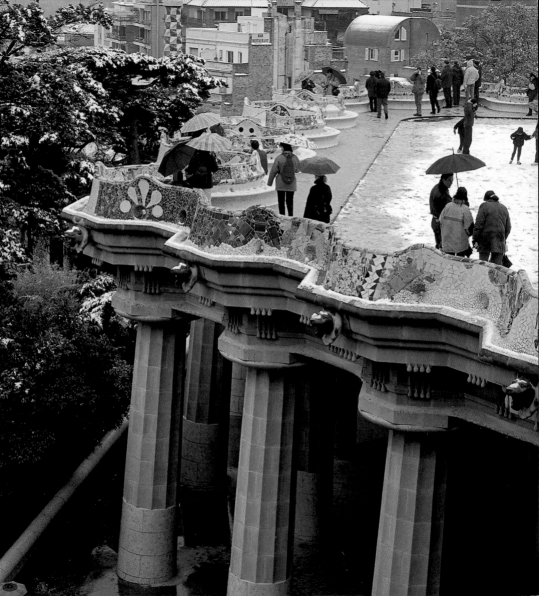

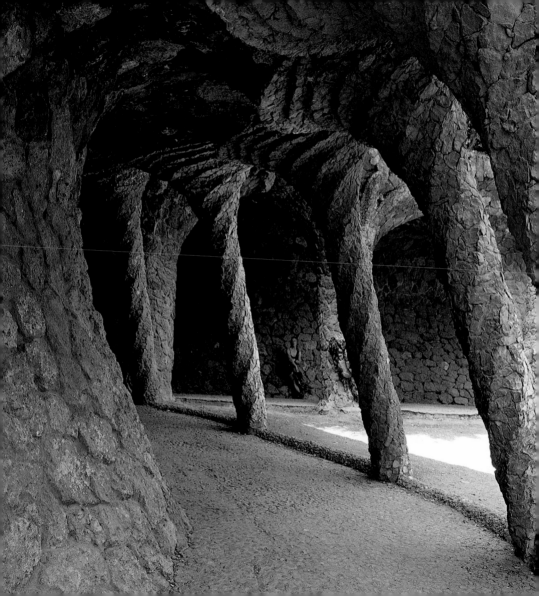

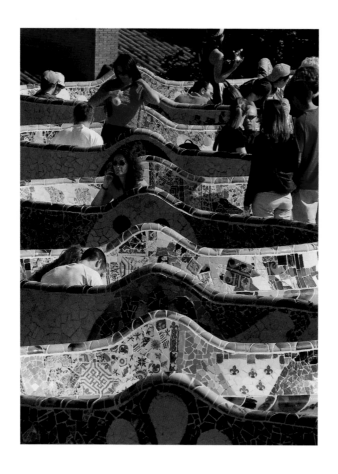

Park Güell

Monastery of Santa Maria de Pedralbes, 14th century →

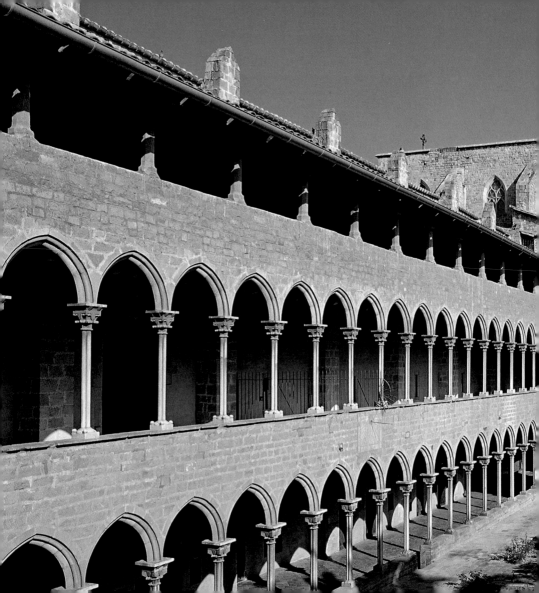

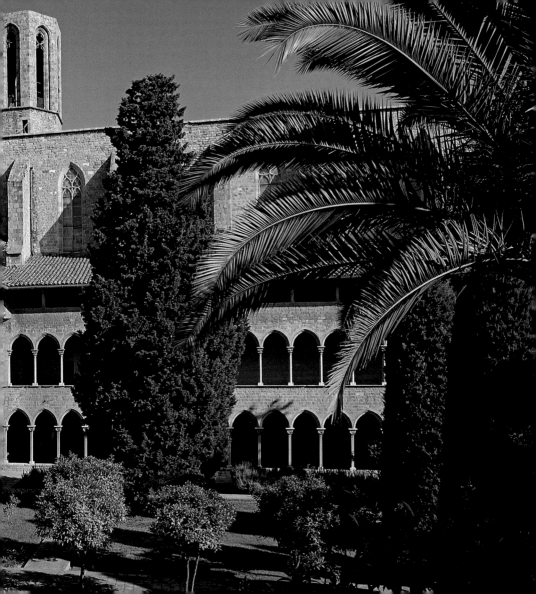

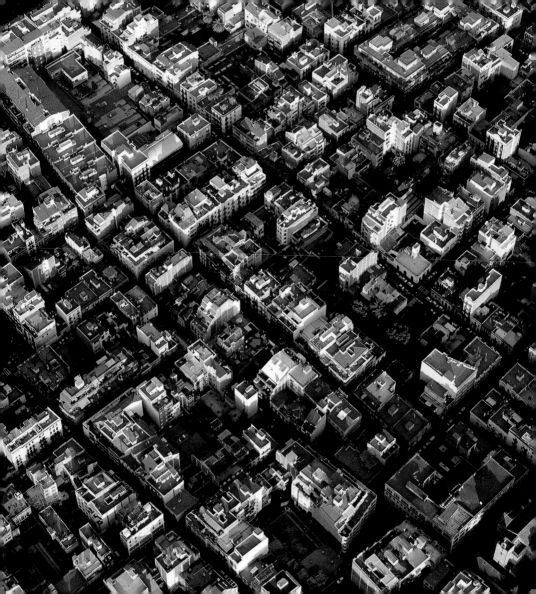

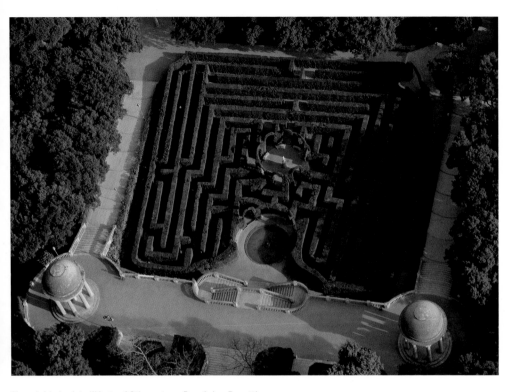

Parc del Laberint d'Horta, 18th century. Doménico Bagutti

Parc de l'Espanya Industrial, 1981-1985.
Luis Peña and Francesc Rius →
Parc de la Creueta del Coll, 1981-1987.
Oriol Bohigas, Josep M. Martorell and David Mackay →→

District of Gràcia

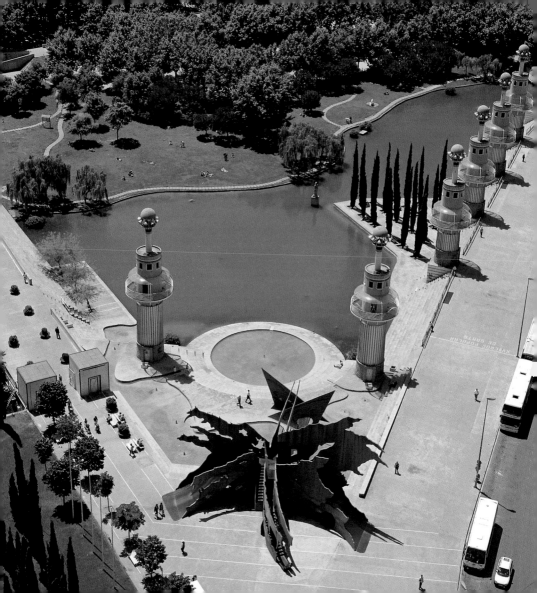

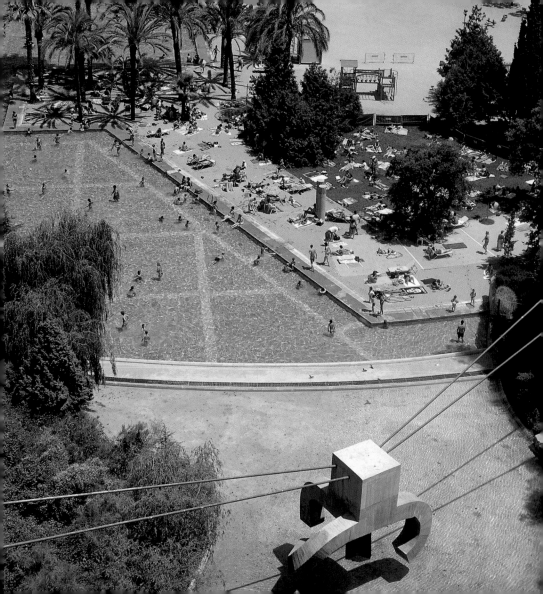

CosmoCaixa, 2004. Robert and Esteve Terradas

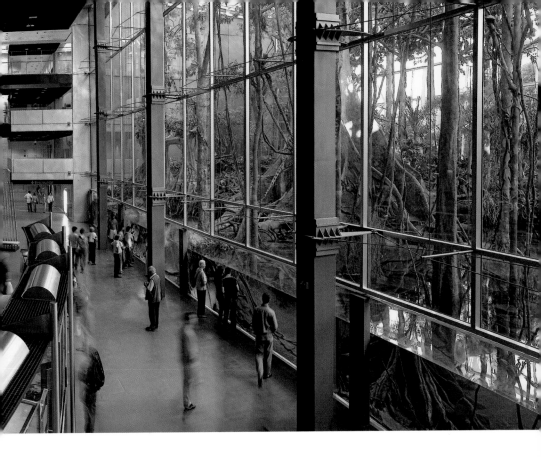

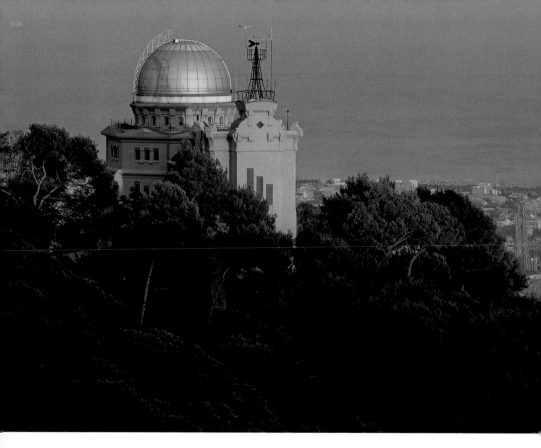

From Collserola the early evening gradually gilds the city while the people of Barcelona watch over it. The Les Aigües road, an old pathway that was used as access to the water deposits that supplied the high part of the city, is today an outing for collectors of perspectives. This great amphitheatre of Barcelona has been devoted to science and technology: the dome of the old Fabra Observatory, the new installations of CosmoCaixa and the viewpoint from Sir Norman Foster's massive communication tower have gained ground over the expiatory temple where, they say, all the sins in the world were pardoned. Here even the blue tram runs at a strictly human rhythm. On one side the chirping of the birds: on the other side the din of all the motors of the untiring city and in the background, the sea of all shades of blue.

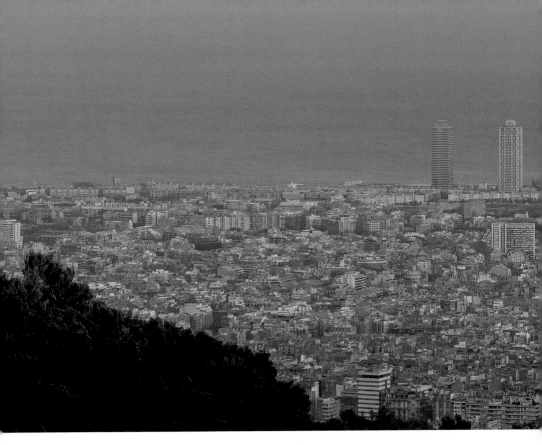

Fabra Observatory, 1904. Josep Domènech i Estapà

Carretera de Les Aigües →
Blue Tram →→

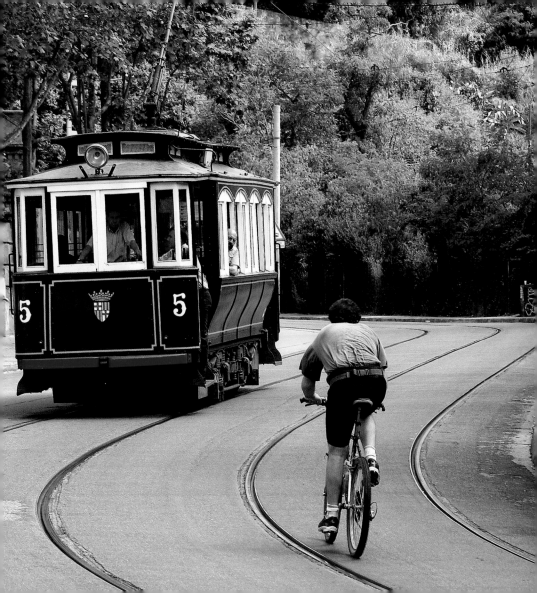

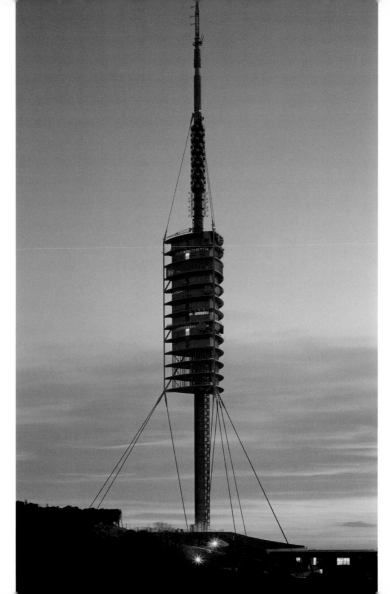

Collserola Communication Tower, 1992. Sir Norman Foster

Expiatory Temple of the Sagrat Cor, 1961. Enric and Josep M. Sagnier

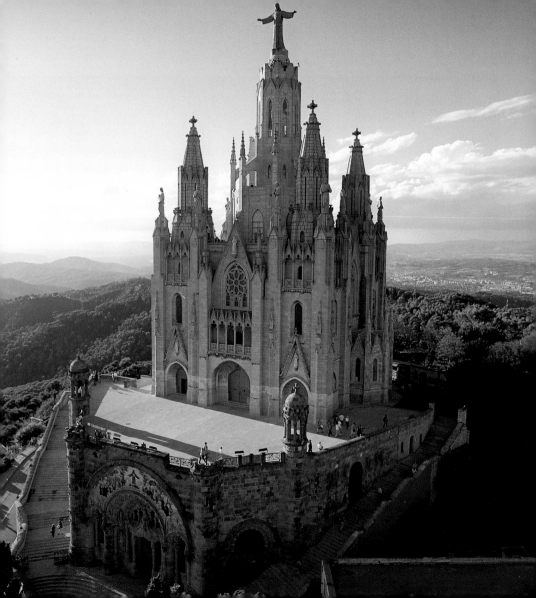

Tibidabo Amusement Park

324

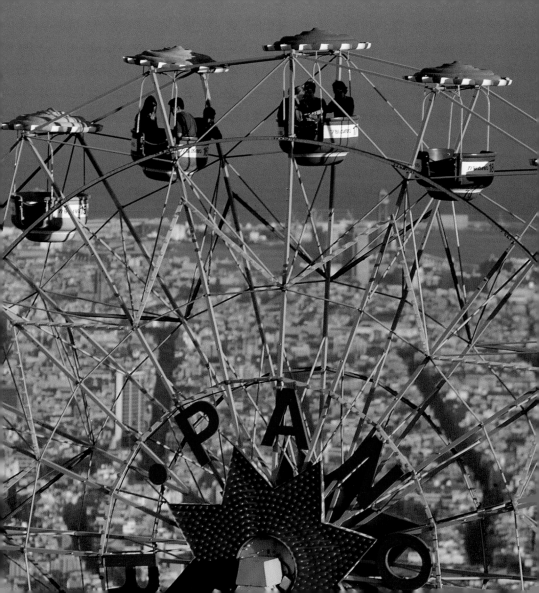

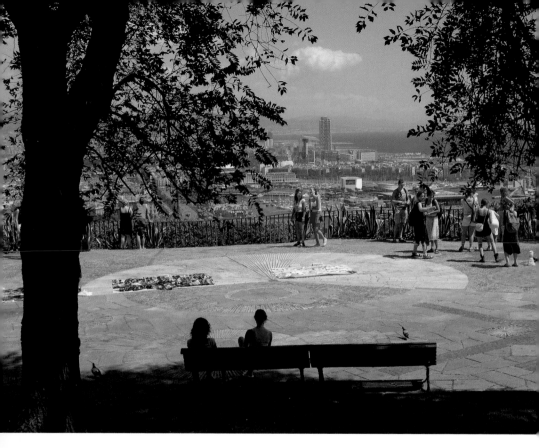

Montjuïc. Mirador de l'alcalde.
This mountain was once a lighthouse and quarry. It was a friend to the city when it acted to defend it from its adversaries, but it was also an enemy when it turned its cannons on its streets below. Montjuïc was the scaffold of the loyalists and is still a resting place for all. It was the nesting place of the shantytowns and the podium of Olympic glories. Today the mountain is a symbol of knowledge and harmony: a new Acropolis that houses museums, theatres, business and lovers. From its terraces Barcelona is within reach. This mountain plays host to Romanesque paintings and paintings still wet, produced by the most recent creative artists. The present and the past, life and the dead, the projected

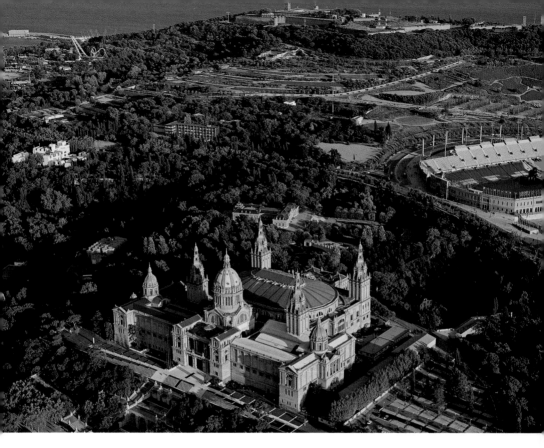

future and the memory have found a common framework on this gently sized mountain. The stones of the city come from here and this gives it a maternal nature, like a woman resting over the plain. The head close to the sea and the legs stretched out so that the people of Barcelona can tickle her.

Montjuïc. Palau Nacional, 1929, Enric Català i Català, Pedro Cendoya and Pere Domènech i Rovira. Home of the MNAC (National Museum of Art of Catalonia)

MNAC, first reform, 1980. Gae Aulenti,
Plaça del Mirador s/n

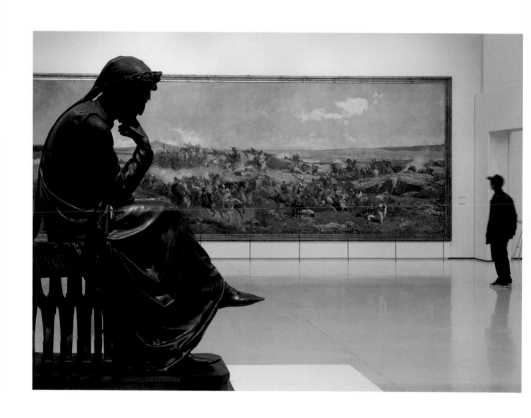

MNAC

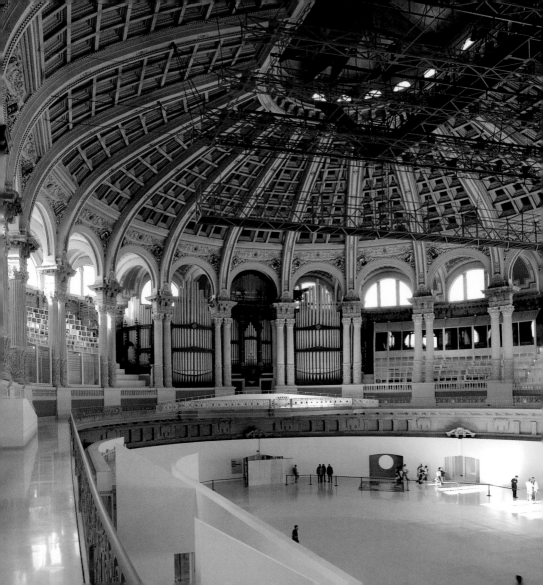

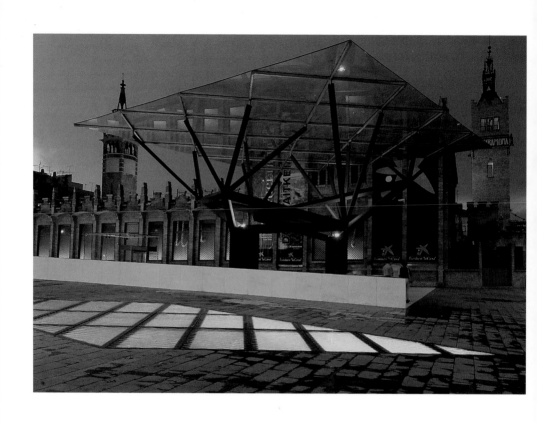

Casaramona Factory, 1911. Josep Puig i Cadafalch.
Remodelling, 2002. Roberto Lerna, Robert Brufau and José Fco. Asarta.
Entrancer and "Tetsuju" sculpture, 2002. Arata Isozaki.
Home of the CaixaForum cultural centre, Avinguda Marquès de Comillas, 6-8

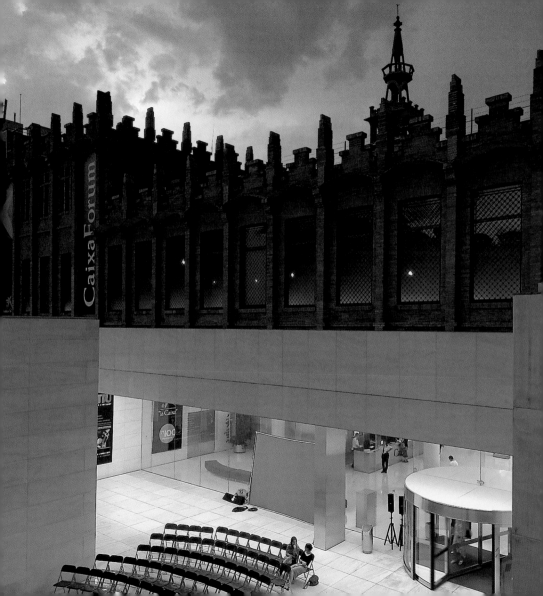

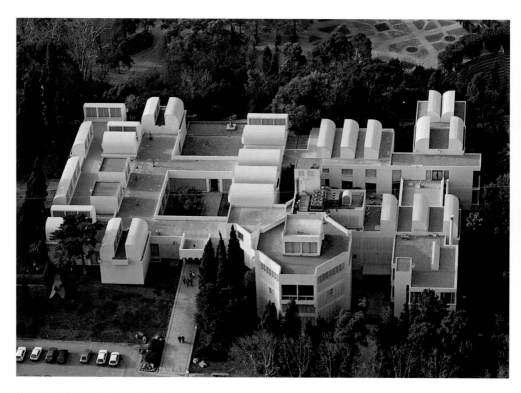

Montjuïc is the small acropolis of Barcelona. From among the woods emerge palaces of art and sports, of theatre and of debate. In the Miró Foundation, contemporary art and the legacy of Joan Miró achieve the miracle of making all the visitors of these perfect halls end up being more beautiful than they really are and making them believe that perhaps the best painting might be the window.

Fundació Joan Miró, 1972-1975. Josep Lluís Sert

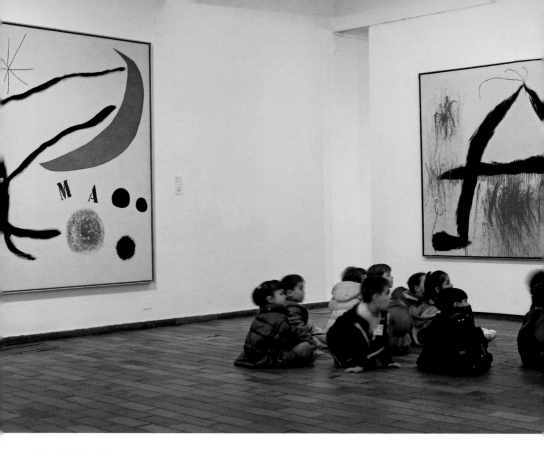

Fundació Joan Miró

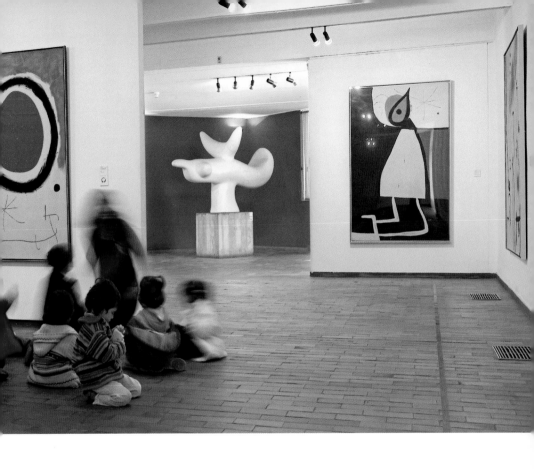

Mies van der Rohe Pavilion, 1929 →
Mercat de les Flors. Cupola by Miquel Barceló, 1986 →→

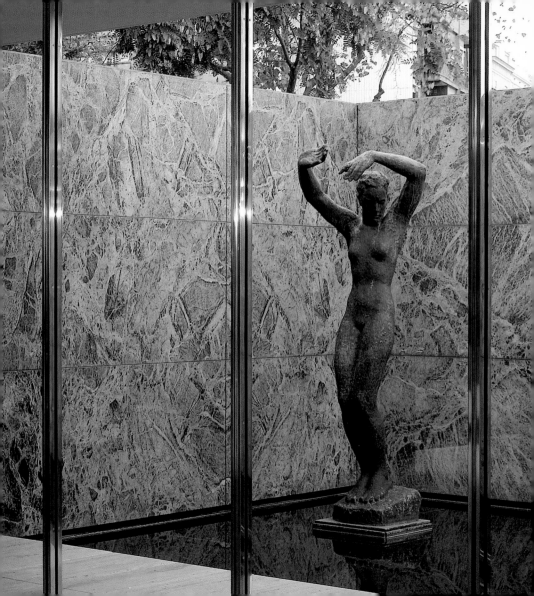

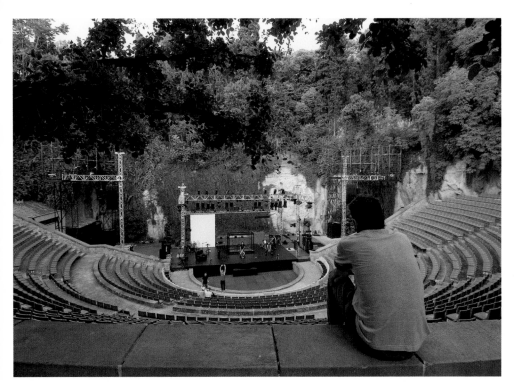

Teatre Grec

Painted ceilings in the lobbies of the City of Theatre and star-filled ceilings on the summer nights of the Teatre Grec festival. Anywhere is a good place for society to meet up as a people and listen in silence to the portrayal and also the doubts offered to us from the stages, the place where it is shown that the well-spoken word is a healer.

Palau Sant Jordi, 1990. Arata Isozaki →
Plaça d'Espanya →→
Font Màgica →→→

Mercat de les Flors

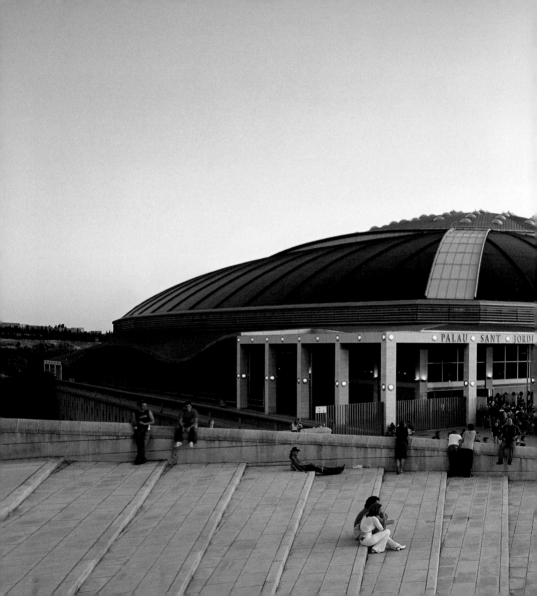

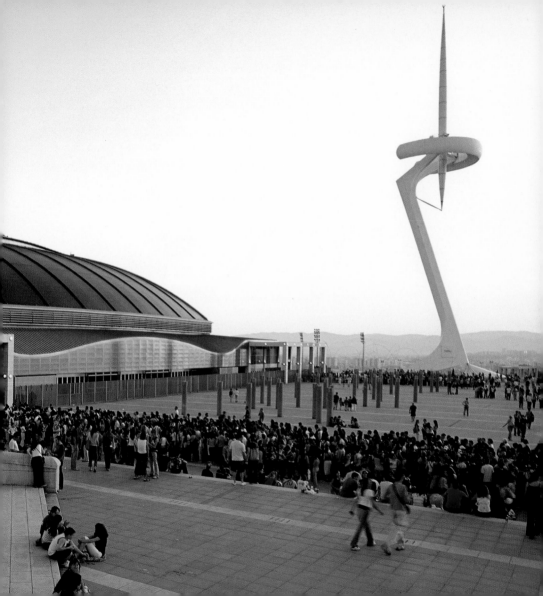

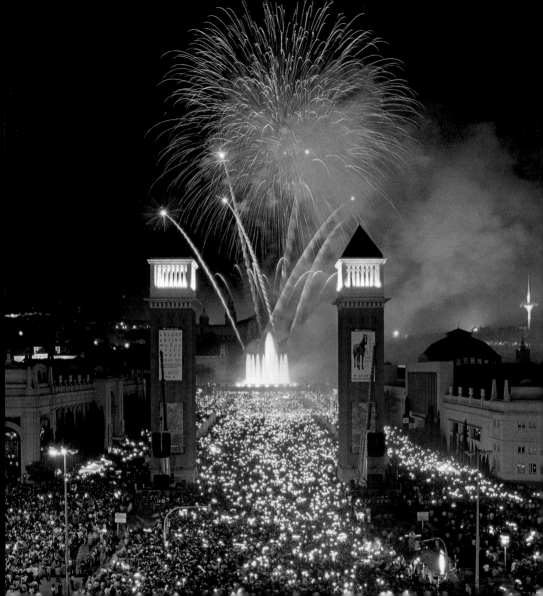

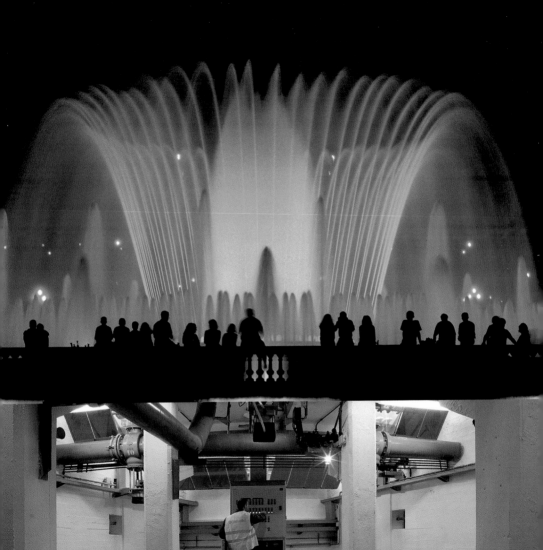

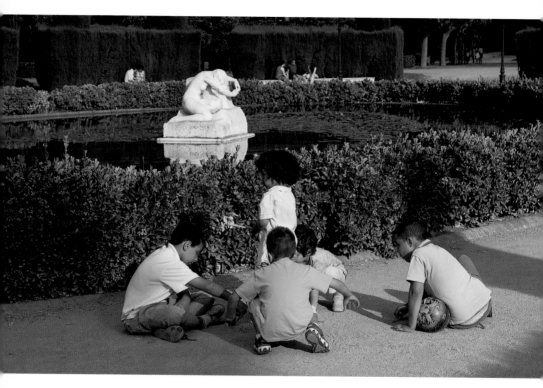

The place that in the early part of the 18th century was
a citadel to watch over the risen up and defeated city,
is today the area where people go to pass a few hours
and where the people's representatives make their laws.
Museums and auditoriums, theatres and beasts make
this space that was once the domain of cannons into
what is now a permanent park of peace.

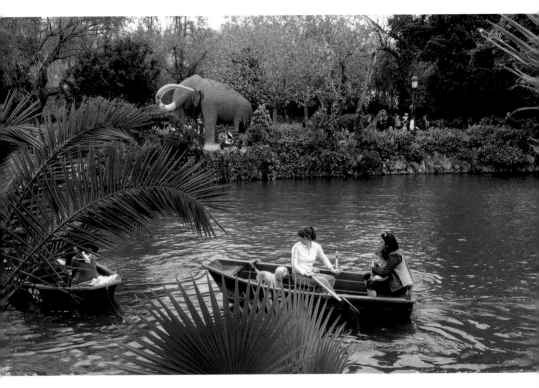

Parc de la Ciutadella

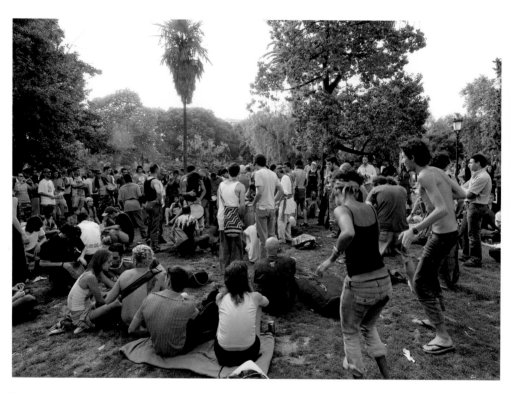

Parc de la Ciutadella

Zoological Park

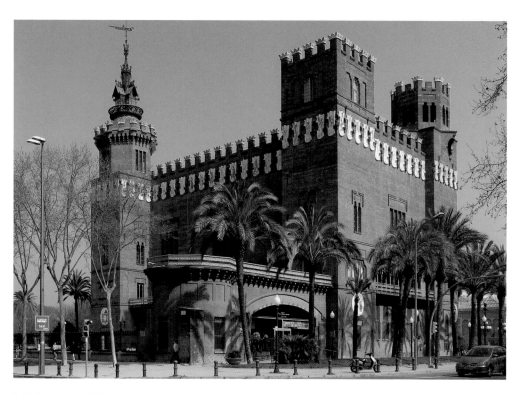

Cafè-Restaurant, 1888. Lluís Domènech i Montaner
Home of the Zoology Museum

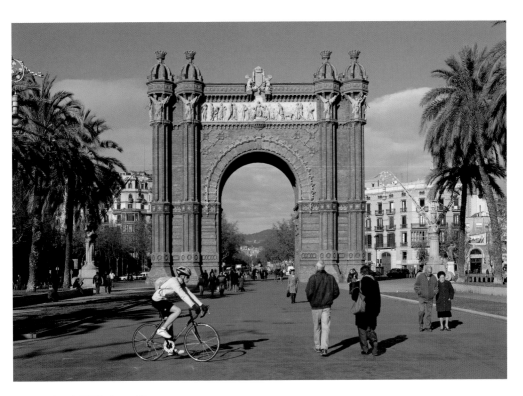

Arc del Triomf, 1888. Josep Vilaseca

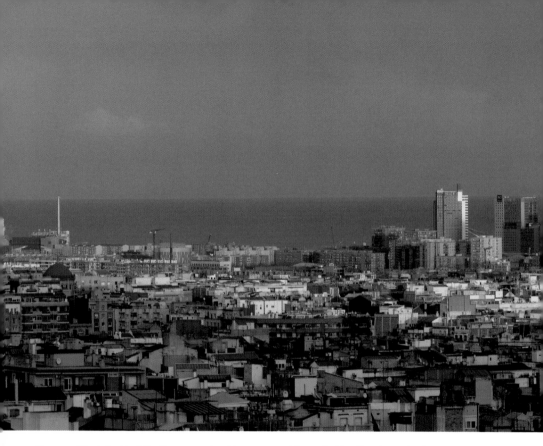

If we say "the tallest building" we are not making any value judgement. The dimensions are simply dimensions, and it is beauty that makes us remember the works of man. In Barcelona it is not about gaining height. Height must be won with authority. A cylindrical building that reaches for the sky with its tip is no better or worse than the polychromed roof of a single-storey market building. The city has no space for growth, but tries to find itself and surprise itself every decade. Gilded fish, tympanums and architraves that housed the old and which now house that which is modern, delightful waters where the lateen sail still survives, enormous musical boxes and hotels that touch the clouds. They are the new cathedrals of the 21st century. In the street the small human silhouette gets the benefit of grandeur.

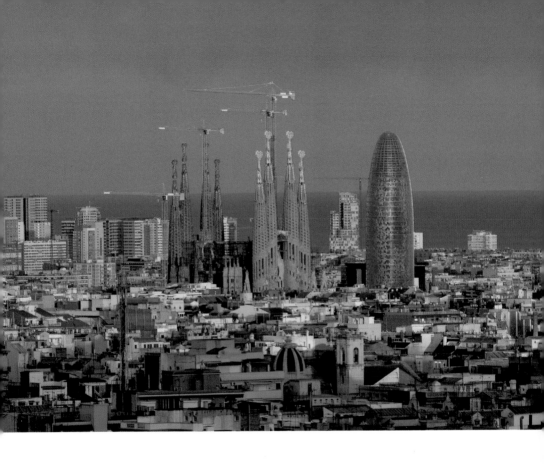

Plaça de les Glòries, 1992. J. A. Acebillo →
Bac de Roda Bridge, 1987. S. Calatrava →→
Agbar Tower, 2005. Jean Nouvel →→→

353

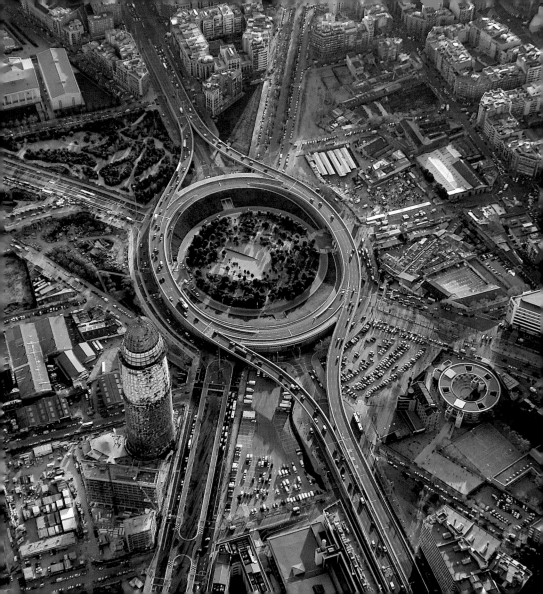

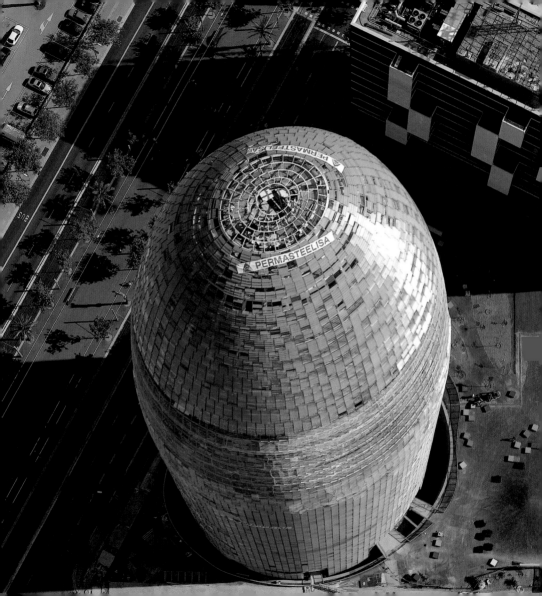

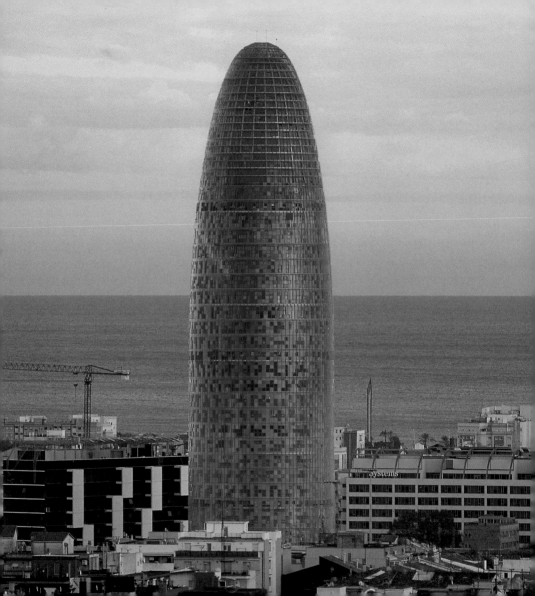

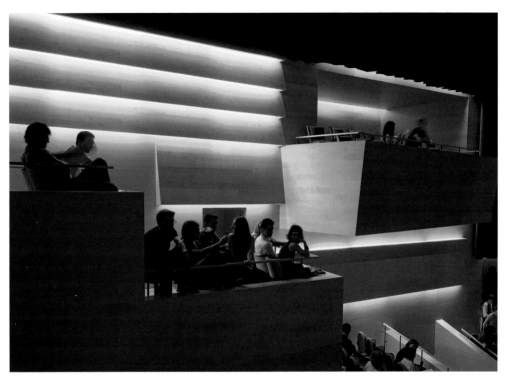

Municipal Auditorium of Barcelona, 1988-1998. Rafael Moneo

National Theatre of Catalonia, 1987-1997. Ricardo Bofill

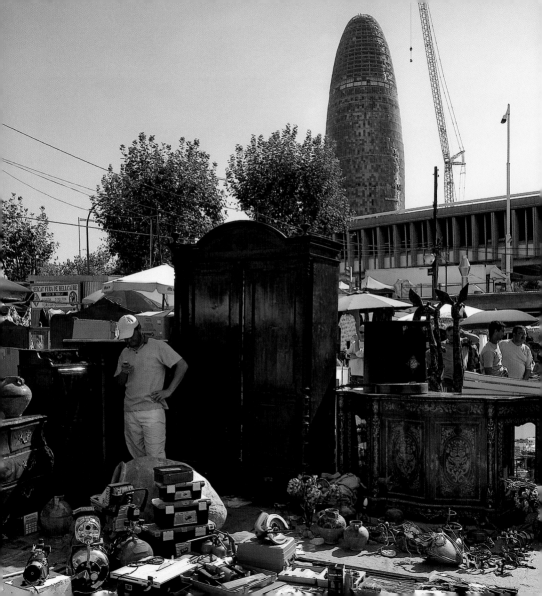

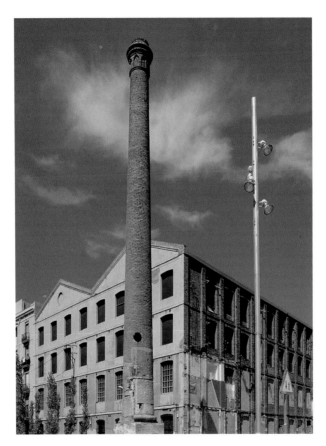

Can Saladrigas, 1884. Joan Barba and Francesc Pascual.
Carrer Joncar, 27-45

Mercat dels Encants (old market)

In this district, Poble Nou, which in years gone by was considered the factory of Spain, today the steam chimneys no longer steam. The old work pathways are now full of children playing and the beaches that were tinged with blood from the executions after the Civil War are now an invitation to the democratic laziness of the bathers. The city of leisure and sun has gradually invaded that Barcelona of forges, smoke and grease. They say the industry of today is clean and silent. A new district –district 22@– is growing over the old district and slowly houses activities and inventions half way between reality and magic. The construction cranes are today the grand dynamic monuments that give life to an extremely new Poble Nou [New Town].

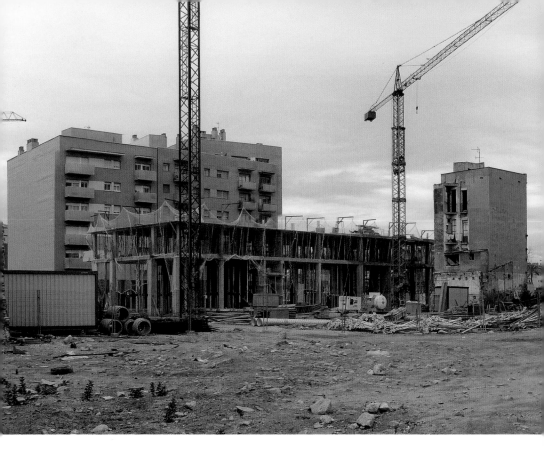

363

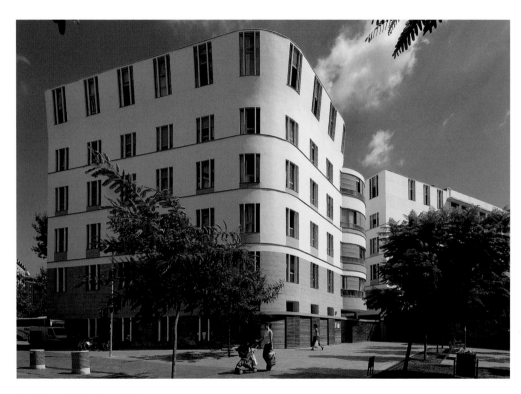

Fort Pienc, 2003. Josep Llinàs

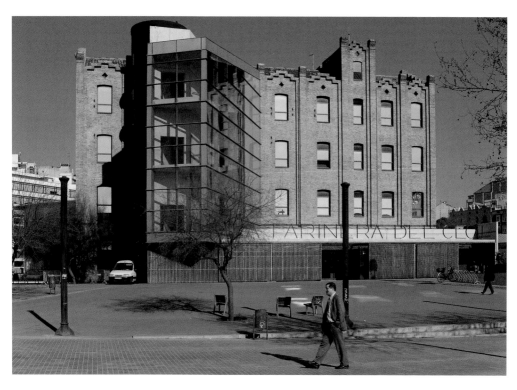

La Farinera del Clot, 1908. Josep Pericas i Morros.
Gran Via de les Corts Catalanes, 837

Dona i ocell, 1983. Joan Miró / *Mistos*, 1992. Claes Oldenburg ↗
Cap de Barcelona, 1998. Roy Lichtenstein →

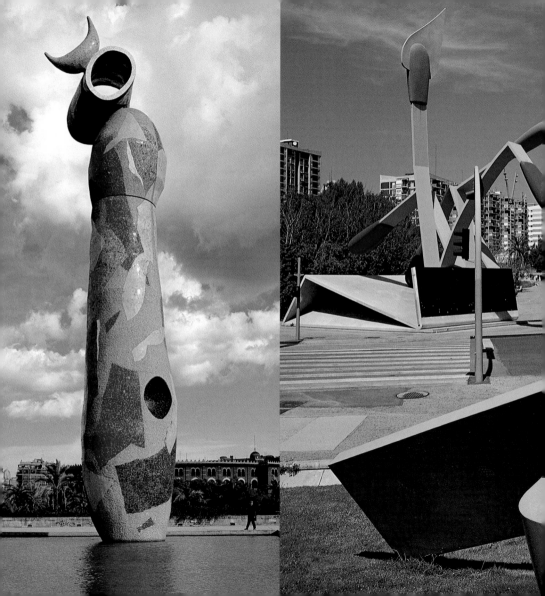

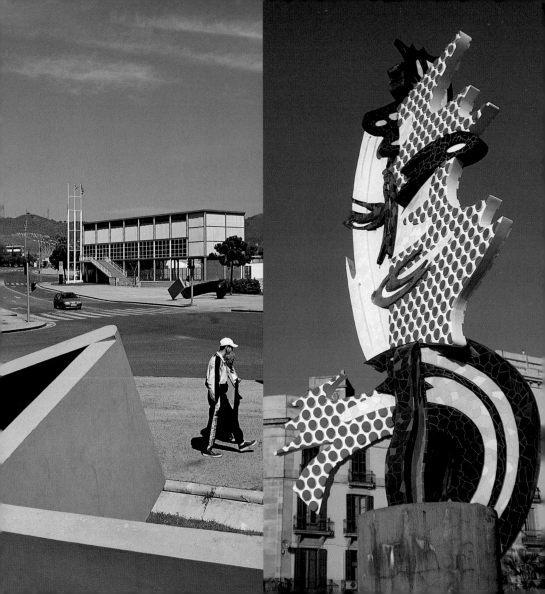

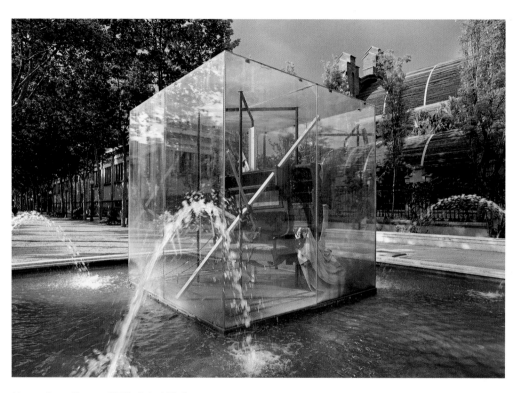

Homenatge a Picasso, 1983. Antoni Tàpies

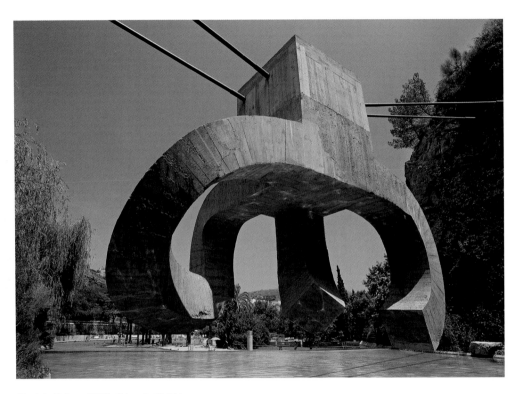

Elogi de l'aigua, 1987. Eduardo Chillida

1 *David i Goliat*, 1993. A. Llena / 2 *Ones*, 2003. A. Alfaro
3 *Escullera*, 1988. J. Plensa / 4 *Dime, dime, querido*, 1986. S. Solano
5 *Poema Visual*, 1984. J. Brossa / 6 *Marc*, 1997. R. Llimós
7 *Forma i espai*, 1966. E. Serra / 8 *Monument a S. Roldán*, 1999. E. Úrculo →

369

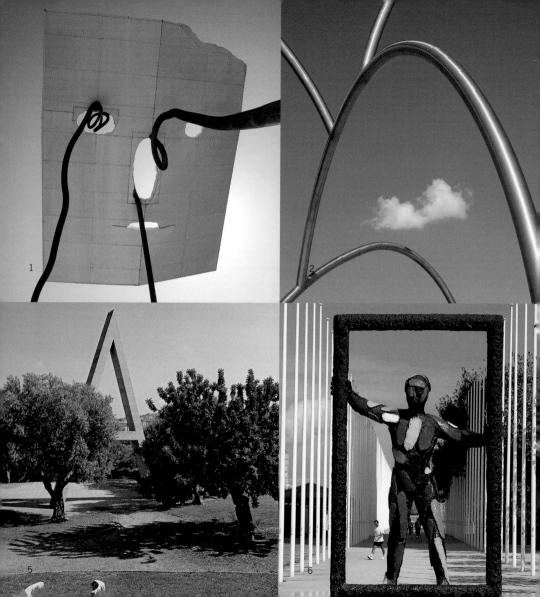

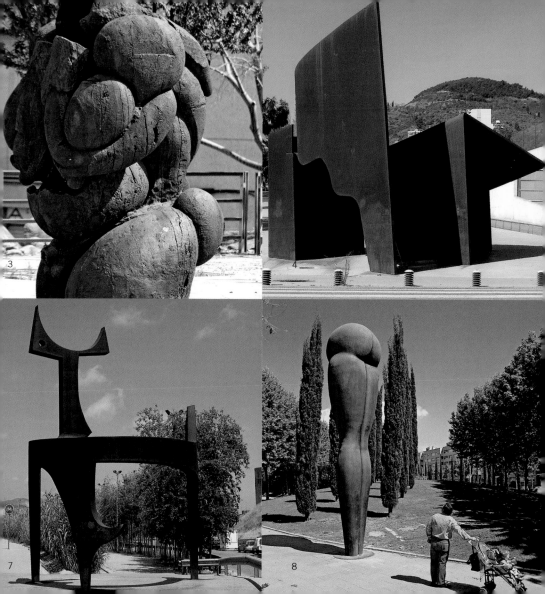

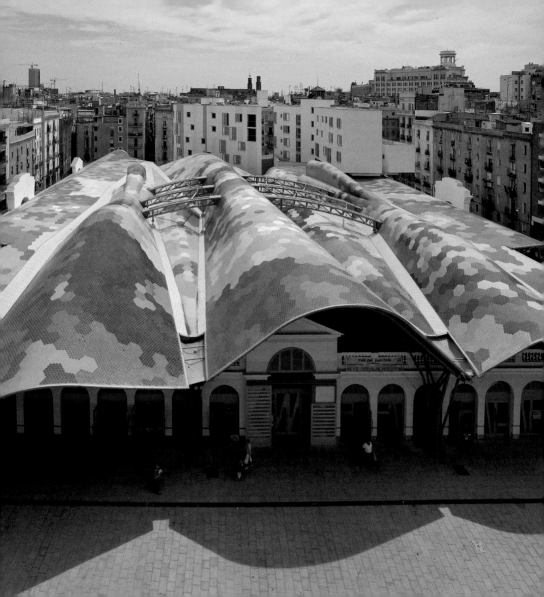

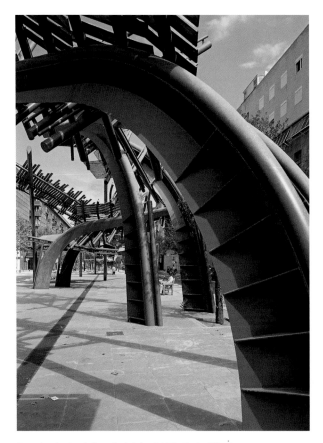

Pergolas in the Avinguda Icària, 1992. Enric Miralles

Santa Caterina Market, 2005.
Benedetta Tagliabue

Parc de Diagonal Mar, 2002.
Enric Miralles and Benedetta Tagliabue →

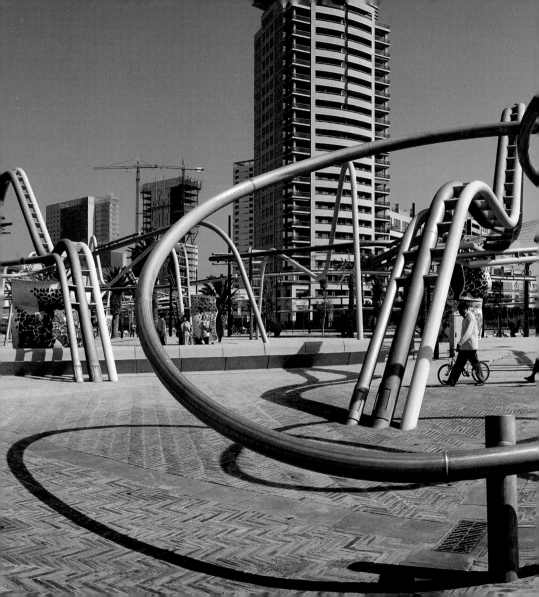

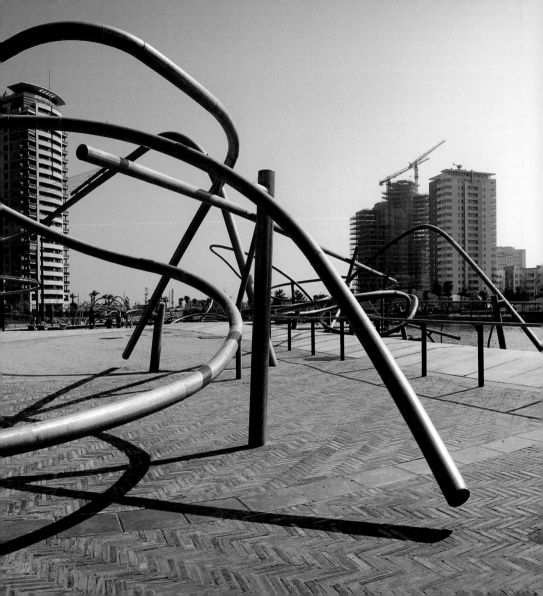

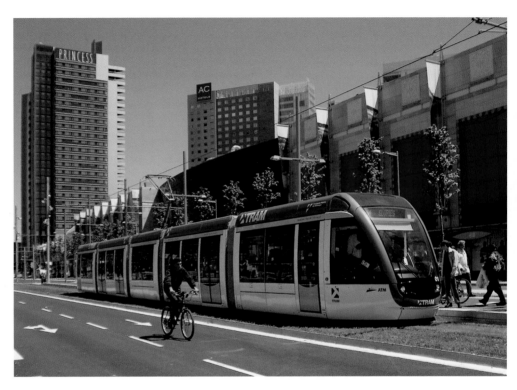

Few street names are as explicit as that of the Avenida Diagonal. It is both name and description. Unbroken for many years now, it is a line that crosses the city without partitioning it. The Diagonal has finally reached the point where the houses, the sea and the river make up the origin and the end of everything. If at any time there has been a streetcar named Desire it was this green and white vehicle that has put the fashionable seaming into an old ripped rag of Barcelona.

Diagonal Mar. Hotel Princess Barcelona, 2004. Òscar Tusquets

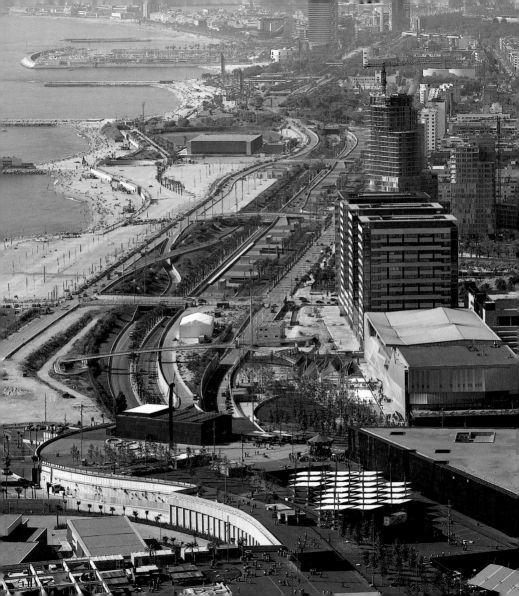

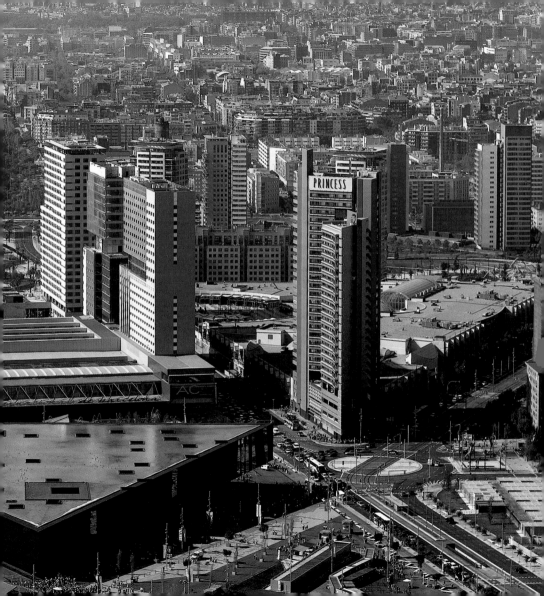

Placa Fotovoltaica, 2004. Elies Torres and J. Antonio Martínez.

In the summer of 2004 the cultures of the world arrived at the large level area of ground of the Forum. It was not a fair. Nor was it a competition. The Universal Forum of the Cultures was an affirmation in dialogue and in the equality of the peoples of Humanity. Now that the Forum is just a memory, what remains as intangible is the stamp of those months in which spectacle, reflection and mutual respect made a city more complete and a morally better citizenry.

Edifici Forum, 2004. Herzog & De Meuron

Diagonal Mar →
View of the Forum from the Hotel Princess ↦

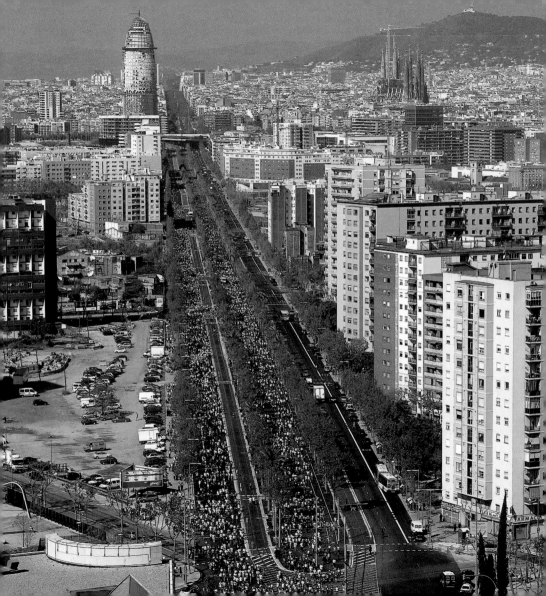

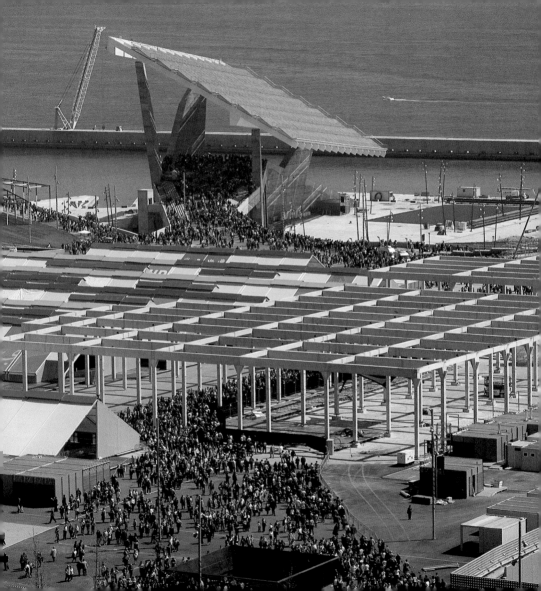

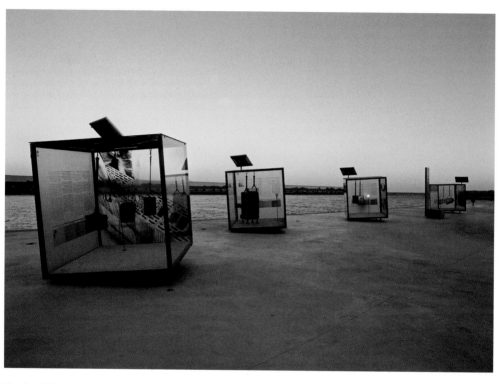

The Good Idea Boxes.
Forum 2004

CCIB. (International Conventions Centre of Barcelona), 2004.
José Luis Mateo

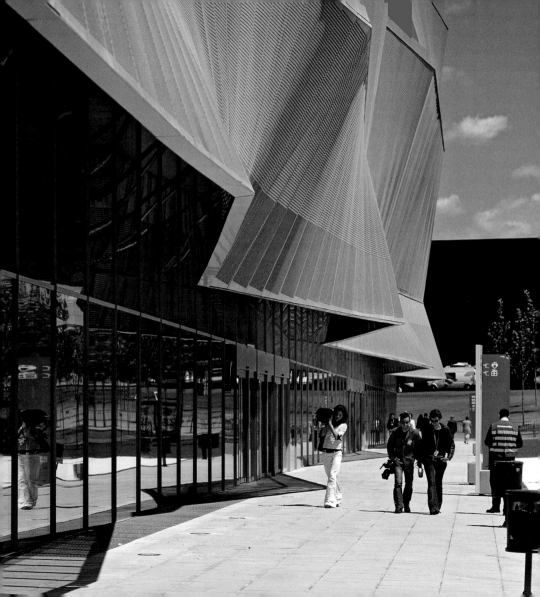

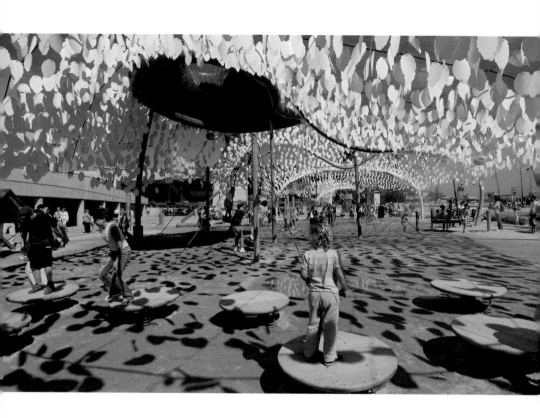

Universal Forum of the Cultures. 2004

392

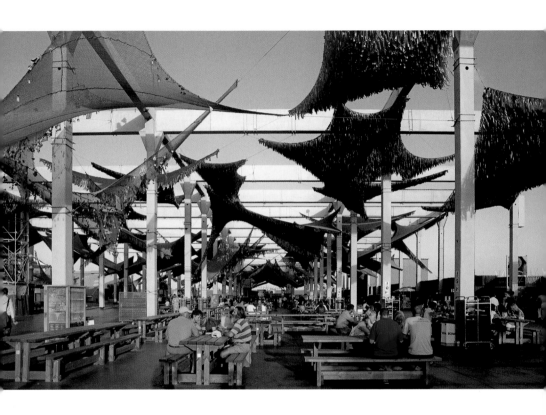

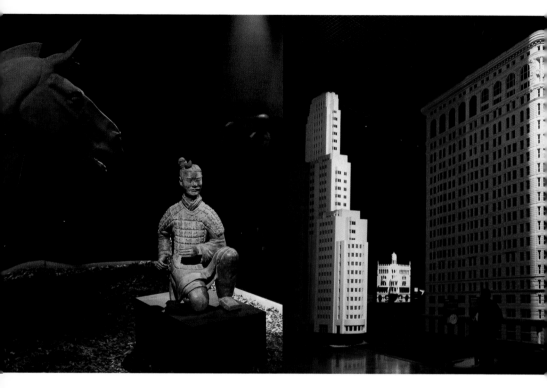

Darkness is necessary so that doubts sparkle and beauty expresses itself. The exhibitions of the Forum 2004 will stand as great moments in the memories of those who visited them. The texture of the warriors of Xian, the reflection about the construction of cities, the urgent need to avoid the world walking towards disaster or the exaltation of all the voices of the world that make us all equal but with different accents. Other Forums in other parts of the planet will come later and continue this work. It will always be necessary to say that it all began in Barcelona. And the different voices will express the same dream of making the worlds move. The world in which we will all have to fit into and the small world of each an every one of us.

394

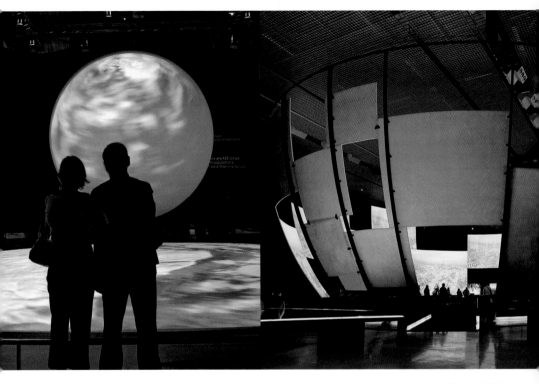

Exhibitions of the Forum 2004:
Warriors of Xian; Cities, corners; Inhabiting the world; Voices

Forum 2004. The giant of the seven seas →

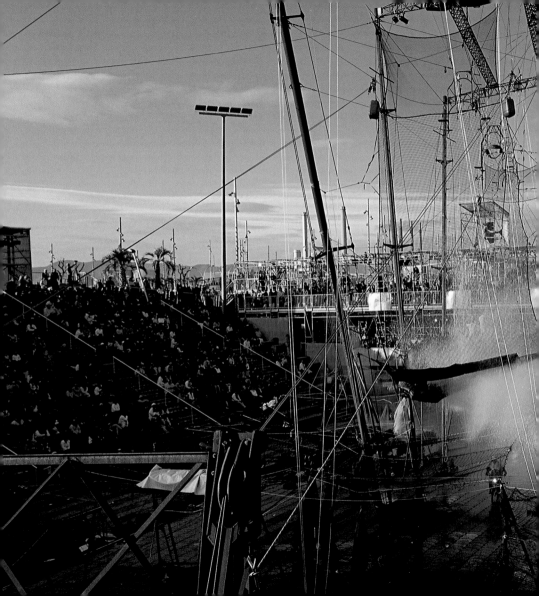

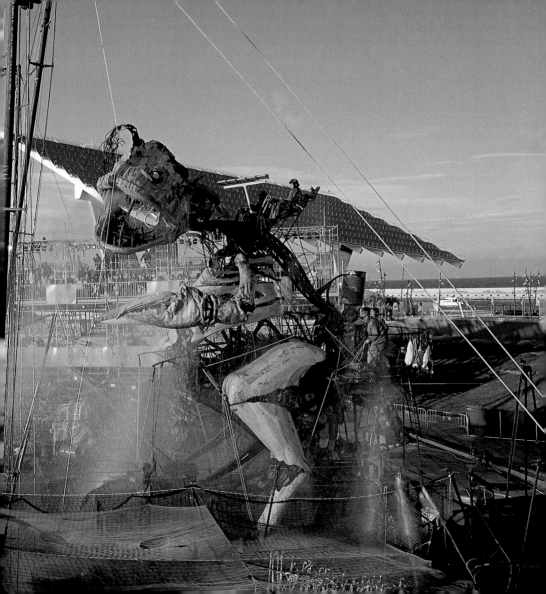

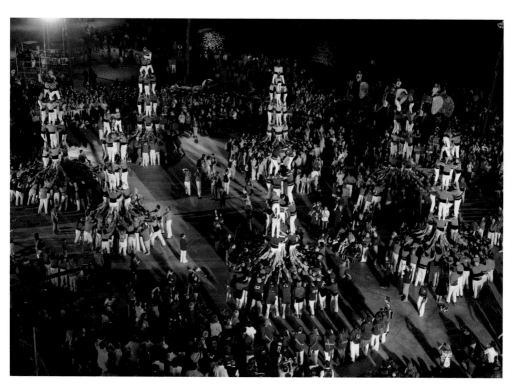

Closing ceremony of the Forum 2004.

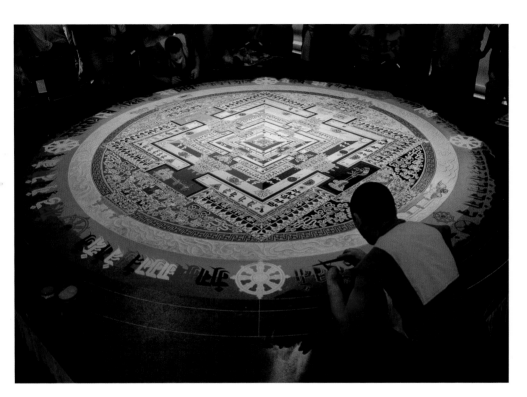

During the Forum six Buddhist monks set up the biggest Mandala in the world in the Rambla. It took weeks to place the millions of grains of coloured sand that makes them, but once completed it was thrown into the sea in a ritual that reminds us of the fleeting nature of our existence.

An urban legend attributes to the writer Manuel
Vázquez Montalbán the creation of the sentence, almost
a Barcelona aphorism, "Barça is more than a football
club". The now hundred-year-old Futbol Club Barcelona
occupies the position in the Catalan collective
consciousness where in other places they have
liberating heroes or patriotic institutions

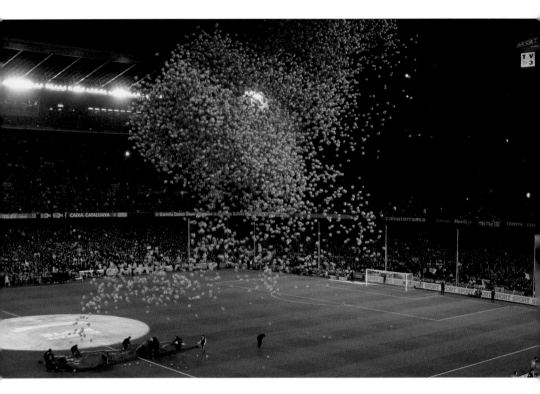

Camp Nou, stadium of FC Barcelona

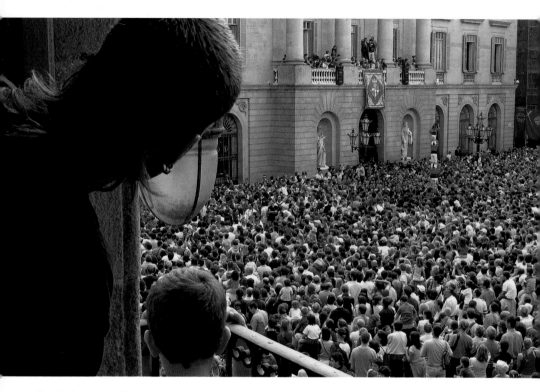

The Festivals of the Mercè. *Castellers* (human towers) in the Plaça Sant Jaume

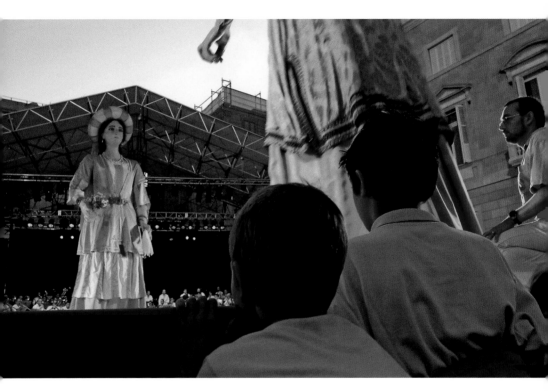

The Festivals of the Mercè. Giants in the Plaça Sant Jaume

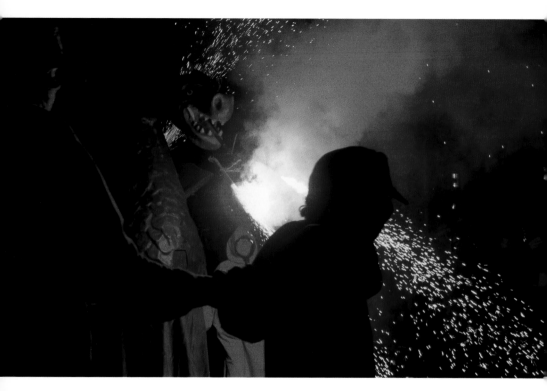

The bottom of the Mediterranean, in the crucible where each dawn the solar and incandescent disc that rises up from the sea is forged, must be the inexhaustible mine of fire that presides over all the festivals of the Barcelona people. Bonfires for the solstice of Saint John, devils, gunpowder, sparks, smoke and running. The domination of fire is a way of confronting one of the four elements and defeating it. In these festivals the condensation of what is called Catalan *rauxa* [rage] is a long way from the so-called *seny* [good sense] of the national dance which is the Sardana. In fire is purification but there is also a strange flirting with the hidden forces of the earth. The festival bells ring out in the churches and on the streets the gunpowder explodes. In who would we trust our souls?

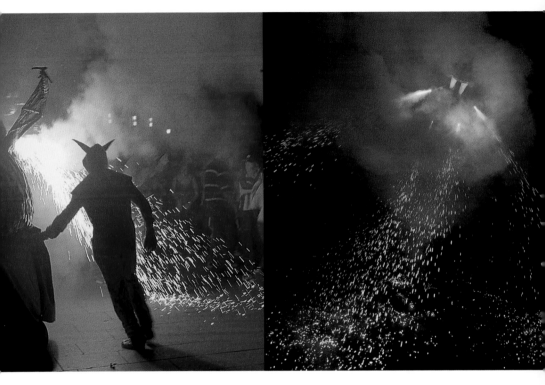

Correfoc, the firework procession of the Festivals of the Mercè

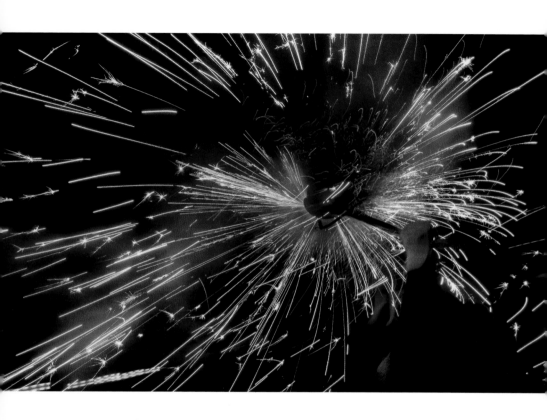

Correfoc, the firework procession of the Festivals of the Mercè

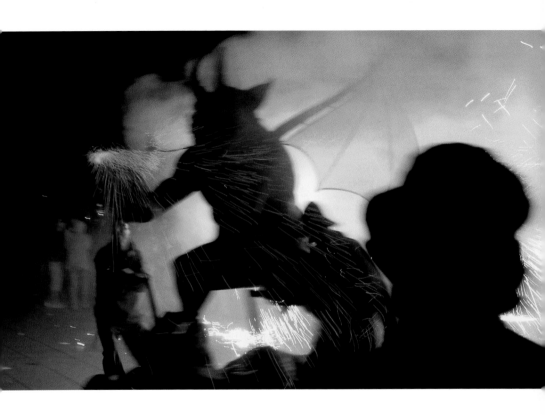

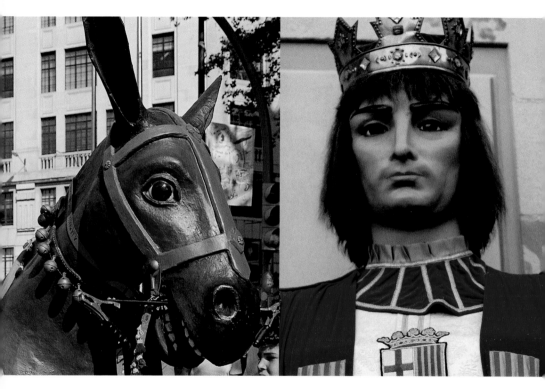

Aware of the smallness of all things human, Barcelona has a cardboard-like representation of its most venerable personages. For once the Kings will not do what their authority allows them to but what the people, hidden beneath their capes of stage machinery, make them do. Sometimes smallness will also become grandeur, when men, women and children support each other to defeat fear and defy gravity with the strength of arms and backs. Perhaps they do not get high enough to take a bite out the moon, but they will feel proud of having raised the youngest ones towards new horizons. Everyone takes part of the *castells* and they are a demonstration that is always in favour and never against anyone.

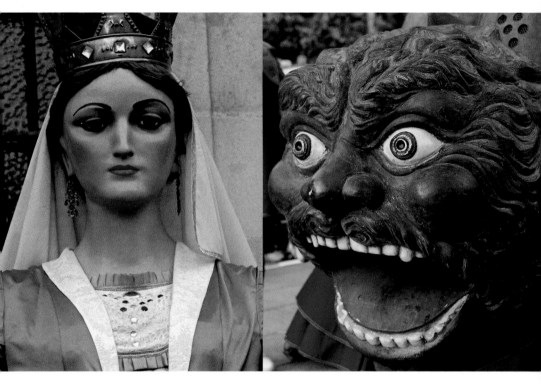

Mulassa, Gegants from Barcelona and *Tarasca*

409

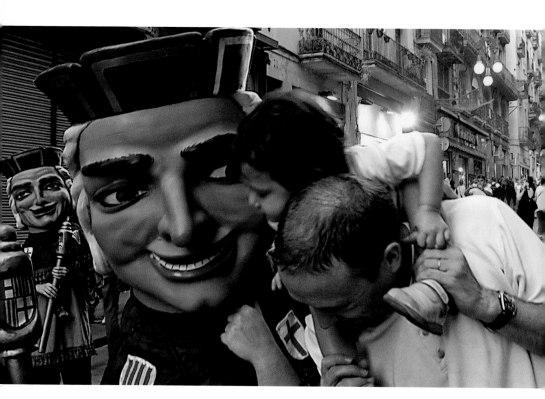

Festivals of La Mercè

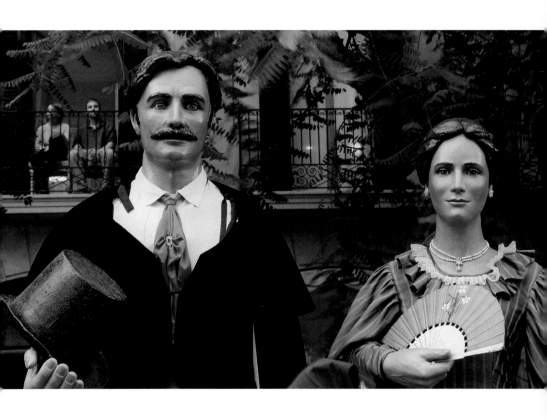

Castellers in the Plaça Sant Jaume →

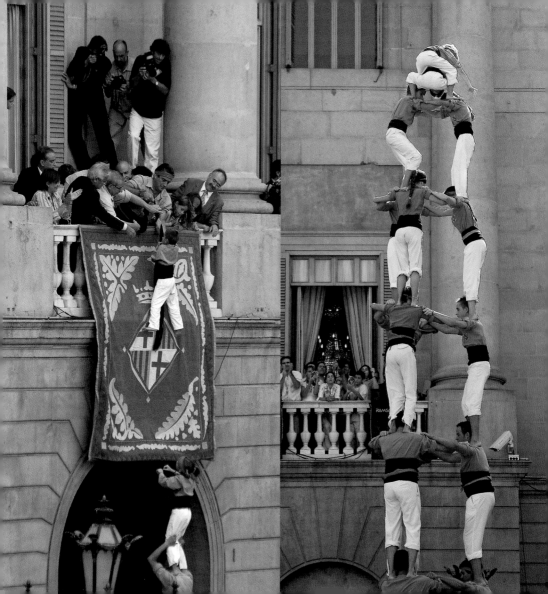

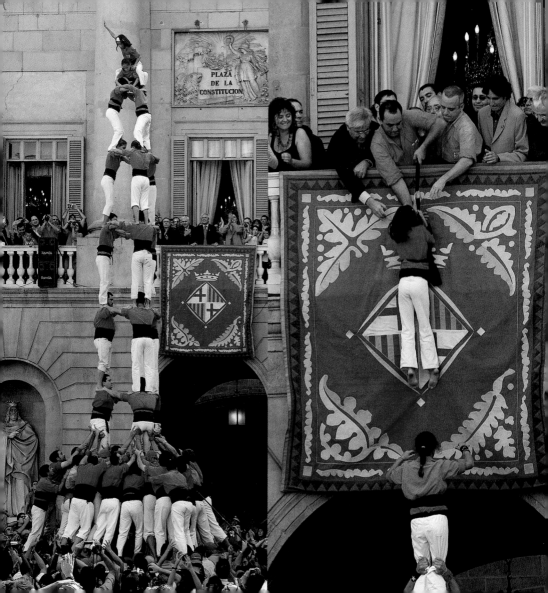

Festivals of La Mercè

415

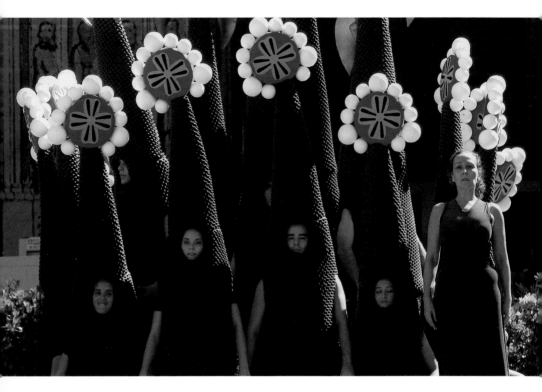

Festivals of Sant Roc

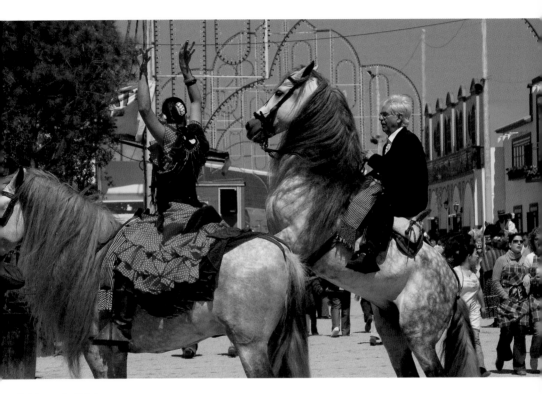

Catalunya April Fair

And the festival goes on in the districts. The satisfaction of being from Barcelona is complemented with the pride of the most adorned street. The chairs come out onto the pavement again and the squares are the cultural centres they always were before television imprisoned people in their homes. It is also sometimes necessary to go onto the street to protest against an unjust world and to feel that you are one among many.

This is also the Barcelona that can do without the architecture and urban planning, because cities are, above all else, people. The human landscape, in these days of emergency, is a wave of arms that seek out other arms and one single step that walks and spreads to the most recently arrived. The festival, in Barcelona, does not usually have single stars. At the end of the day the most important thing of all is the result.

Festivals of Gràcia

The city, which in its medieval splendour, created the Consulate of the Sea, the first legal framework that for centuries controlled trade throughout the Mediterranean, continues being one of its most important cargo ports and an avant-garde centre in design and wholesale trade. The new shops, the new bars and hotels today occupy the old sites of Barcelona's trading centre.

420

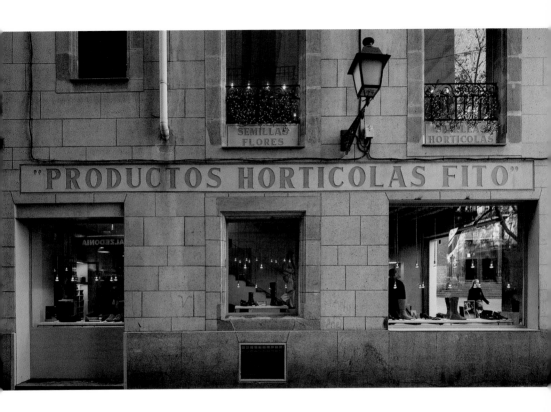

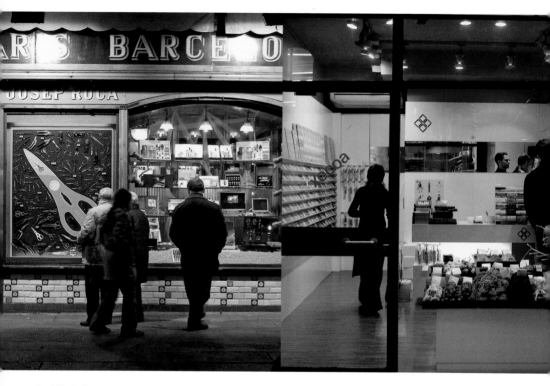

Cuchillería Roca

Xocoa

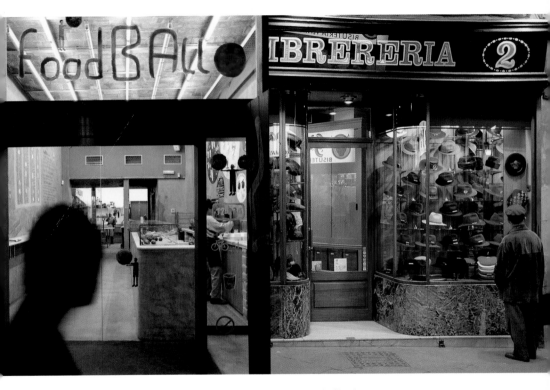

FoodBall

Sombrerería Obach

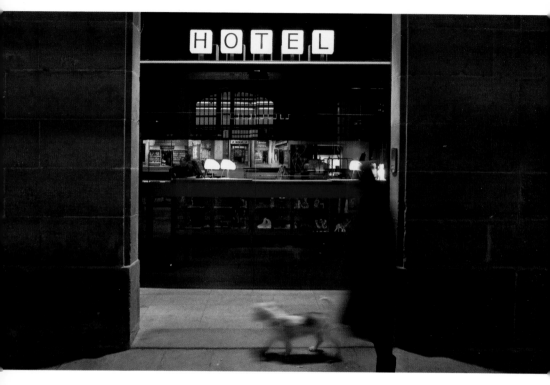

Hotel Camper

Bestial

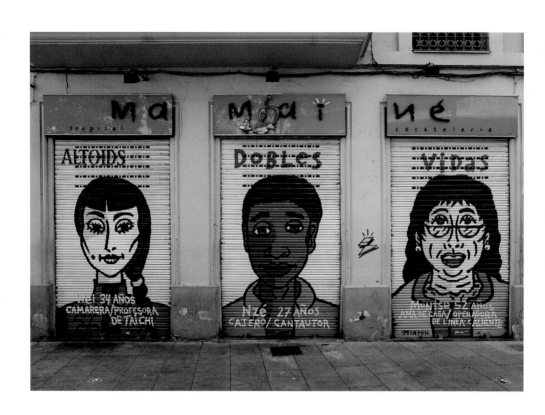

Barri de la Ribera

426

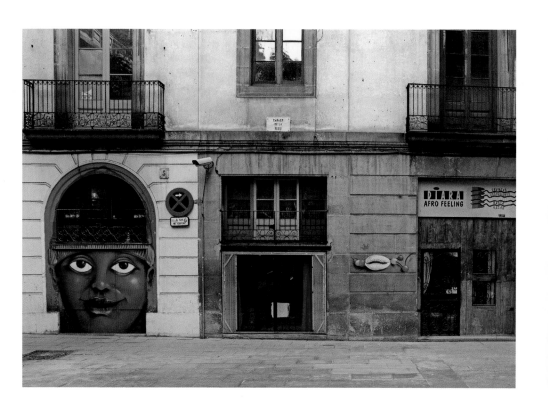

Carnavalona: street carnival led by Carlinhos Brown held in
Passeig de Gràcia during the Forum →

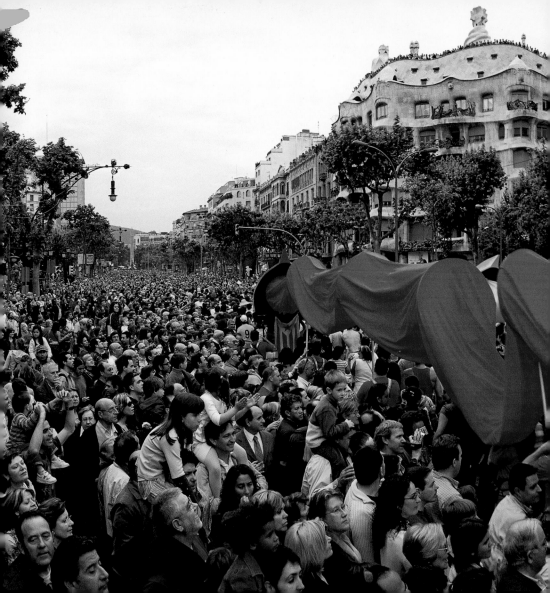

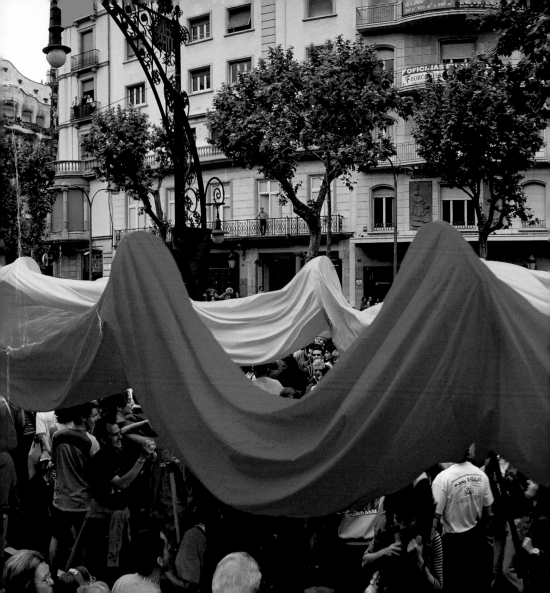

published by

Triangle Postals S.L.
Carrer Pere Tudurí, 8
07710 Sant Lluís.Menorca
tel. 93 218 77 37
www.trianglepostals.com

editor

Ricard Pla, Pere Vivas

photography

© Pere Vivas

© Ricard Pla / Pere Vivas (210, 212, 213, 214,
215, 252, 253, 267, 281, 282, 284, 285, 288, 289,
292, 294, 295, 296, 297, 389, 428)

© Ricard Pla (40, 100, 132, 134, 135, 141, 154, 170,
191, 202, 224, 304, 347, 350, 390, 392, 393, 398,
399, 416, 418, 419)

© Juanjo Puente (69, 75)

© Juanjo Puente / Pere Vivas (50, 192, 299)

© Ramon Pla (349, 371)

© Antonio Funes (361, 401)

© Jordi Puig / Pere Vivas (54, 55, 180)

© Joan Colomer / Pere Vivas (126)

© Lídia Font / Pere Vivas (243)

© Casa Batlló / Pere Vivas
(228, 270, 272, 273, 287, 290, 293)

© Fundació Caixa Catalunya / Pere Vivas
(20, 274, 277, 280, 286, 287)

© Successió Miró, 2005 / Pere Vivas (335, 336)

text

© Joan Barril

translation

Steve Cedar

design

Martí Abril

layout

Mercè Camerino, Aina Pla

coordination

Paz Marrodán, Juan Villena

printed by

Nivell Gràfic

ISBN: 84-8478-176-3
Dipòsit Legal: B-31.401-2005